HAUNTED
MANITOU SPRINGS

STEPHANIE WATERS

Published by Haunted America
A Division of The History Press
Charleston, SC 29403
www.historypress.net

First published 2011

Manufactured in the United States

ISBN 978.1.60949.347.9

Library of Congress Cataloging-in-Publication Data

Waters, Stephanie.
Haunted Manitou Springs / Stephanie Waters.
p. cm.
Includes bibliographical references (p.).
ISBN 978-1-60949-347-9
1. Ghosts--Colorado--Manitou Springs. 2. Haunted places--Colorado--Manitou Springs.
I. Title.
BF1472.U6W38 2011
133.109788'56--dc23
2011025152

*Dedicated to those who have climbed the mountain
and discovered the Razor's Edge.*

CONTENTS

ACKNOWLEDGEMENTS

A big thanks to The History Press for believing in me and to my commissioning editor, Becky LeJeune, as well as to my project editor, Ryan Finn, and everyone else in production for making me look smart. Also, I want to express my gratitude to the Pikes Peak Library District and Pikes Peak regional historians, as well as for computers and the World Wide Web.

Writing this book became a personal odyssey; special thanks go to all my friends and family who supported me along my journey.

Special thanks to Dad, Mom, Tom, Bix, Everett, Kristy, Kameron, Siddhartha, Mary Jane and Monkeys.

INTRODUCTION
WHY DID I BECOME A MANITOID?

I vividly remember my first visit to Manitou Springs, Colorado. It was the summer of 1969. My family had just moved to Colorado Springs from Southern California. I was a recent kindergarten graduate, and to celebrate, my family went to visit what my astute father called "the hippie village under Pikes Peak." I, however, thought of Manitou as the home of the Indians and couldn't wait to go shopping!

We stopped at the old Ute Trading Post on the way into town. Grandma Jessie bought my brother a cool rubber tomahawk and me an authentic Indian necklace. Grandpa joked that the tiny white beads were made from cat's teeth. I believed him and felt brave wearing something around my neck made from the shattered bones of felines.

Grandma told us that the valley had been a vacation spot since the beginning of time. The American Indians used to make pilgrimages to the valley via Ute Pass. Warring tribes considered the springs to be holy, put down their weapons and wiped off their war paint before entering the sacred valley. When French trappers first explored the area, they found beads and trinkets left near the banks of the springs as offerings. The Victorians also realized the spring's curative value, and when a tuberculosis epidemic occurred in the late 1800s, thousands of people flocked to Manitou Springs, as mineral water and fresh mountain air were considered the only cures for the deadly disease.

After the history lesson, we went to the penny arcade, then to the giant turquoise blue Ute Indian chief fountain. I can still recall the refreshing fizzy

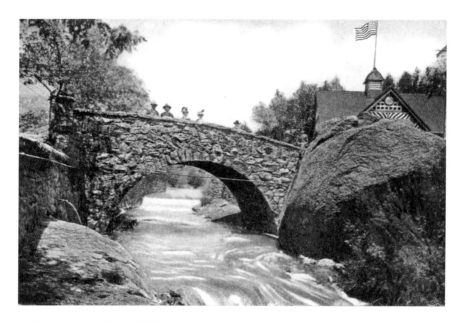

Antique postcard of one of Manitou Springs' many charming stone bridges.

lemonade that we made from the mineral water we collected from its basin. After lunch, we tossed a few coins over the old stone bridge in Soda Springs Park. Grandma Jessie said that it was a toll fee for the resident troll. Manitou Springs seemed like a fairy tale village to me, with its charming hillside cottages and its many stone fences, walls and bridges. As we rolled out of town in my grandparents' little red convertible bug, my brother and I flashed the peace sign to a group of barefooted hippies, and they reciprocated. We laughed until we cried. I remember how cool I thought those teenagers were and vowed that, someday, I would walk around Manitou barefoot. That was more than forty years ago, yet people in Manitou are still just as friendly. I often joke that although the town looks more "yuppified" now, the people are still the same.

My grandmother Jessie use to say that you don't find Manitou—Manitou finds you. Many of the town's residents moved to the hamlet because they felt drawn to the little mountain village. Manitou Springs seems to attract liberated, creative-type individuals, like writers, dancers, actors, singers, painters—in a nutshell, artists. They call themselves "Manitoids," and their common manifesto is to "Keep Manitou Weird." Manitou Springs has had a reputation for being "weird" ever since I can remember, and it is often

jokingly referred to as "Manizoo." The moniker was used long before the chamber of commerce started hosting unique festivals several times a year. People come from all over the country to gather for the annual Emma Crawford coffin races in October, and the New Year's Great Fruitcake Toss is another well-known and popular event.

Where else but Manitou can you see homes that resemble caves, pyramids and castles, all in the same neighborhood. You almost feel like you are in some kind of historical, artistic time warp. In Manitou, almost anything goes; there are no strict covenants or codes about how to paint your house or landscape your yard, and artistic license is freely given. One Santa Fe–style house near the historic Miramont Castle is xeriscaped and boasts a life-sized statue of a rhinoceros posed in Colorado native grass. The metallic "spaceship silver" hue spray painted over the entire rhino is a nice touch, although I'm not quite sure what the artist is trying to convey. The neighbor down the street, also an artist, has three German shepherds that are always seen lounging around on the roof. My five-year-old niece assumed that dogs in Manitou could fly until she realized that the hounds were climbing out the second-story dormer window.

I'm one of several Manitoids in town who drive a hearse. I drive mine for work. I have owned Blue Moon Haunted History Tours in Manitou Springs since 2002.

In 2009, I was diagnosed with the "Big C." Fortunately, I caught it early. It was a wakeup call, as any cancer survivor will tell you. I was reminded that there were still a few things I wanted to do before I die. One of the items on my bucket list was to write a book of ghost stories about Manitou Springs. You can just imagine how delighted I was when The History Press contacted me while I was recuperating last year to see if I might be interested in writing a book about the haunted history of Manitou Springs. I have never considered myself a writer, but I took a leap of faith and gladly accepted the offer.

I tried to write a book that I would want to read. I'm a self-professed history geek; therefore, all of the stories are true and verified by historical facts. Many times I have investigated an alleged haunted location, but no one knows why or what even haunts the place. Especially amusing are the establishments that claim that the place is haunted but *only* by "friendly spirits." I had always heard that Red Crags mansion in Manitou Springs was haunted, so I was thrilled beyond belief when I found an article about a wealthy oilman from Texas who saw a ghost at the estate and was so frightened by the horrifying apparition that he jumped out a third-story window!

Logo of Blue Moon Haunted History Tours.

Not only did I scour the library for resources, but I also interviewed dozens of Manitoids. One guy standing outside the Royal Tavern told me that his house was haunted by a spirit he had named "Casper the friendly ghost." He explained that every weeknight at 5:45 p.m., right before he gets home from work, Casper runs a hot bath for him. Some of the interviews were so funny at times, and keeping a straight face wasn't always easy, but they say that every writer has to suffer for his or her art, so I managed to persevere. It was

easy to find ghost stories about Manitou Springs, as the town's reputation for being haunted is legendary. However, I wanted the book to be about haunted public places, in areas that people could either relate to or visit. That is why there is only one story about a private residence. A map of the haunted locations is provided at the back of the book.

Every haunted site mentioned in this book has been documented as being haunted and has been thoroughly investigated by a team of experienced ghost hunters and psychics. One former team member, Dr. Claude Swanson, has a PhD in physics from MIT and wrote a book, which I highly recommend, called *The Synchronized Universe*. He explains the existence of ghosts using the laws of physics, but in layman's terms. I am obviously a believer. I have been seeing ghosts and experiencing paranormal phenomena since I was seven years old. I was told that I had a gift, from my maternal grandmother, a southern woman, who also had "the shine." My comedic mother, however, blames my sixth sense on the fact that she accidently dropped me on my head when I was a baby.

Manitou parade sign. *Courtesy of the* Pikes Peak Bulletin *newspaper.*

My grandmother instilled a love of storytelling in me long ago. We used to snuggle in bed at night, and I would listen to her tell ghost stories and folk tales about her childhood home in the Ozarks. One of my favorite stories was about my great-great-grandmother, a midwife and healer, who knew herbal cures and could cast magic spells. Grandma also told me that she was named after Jesse James because our cousin rode with the James Gang and was none other than James Cummins, who was infamously known as "Windy Jim," the only gang member who lived to tell about it, as they say. He wrote a book exploiting their notorious adventures that was published in 1904, and he died a wealthy old man.

My Grandma Jessie loved Manitou Springs and fostered that love in me. I think she would have gotten a big kick out of me writing this collection of true Manitou Springs ghost stories, and I hope that you will enjoy them as well!

Manitoids are a proud people who laid stake to the region shortly after the American Indians were ruthlessly chased away. They are a group not limited to race, religion, age or species. They like to engage in artistic pursuits but are not limited to them. Manitoids don't have to live in Manitou, though, because being a Manitoid is also a state of mind. All Manitoids have a creed, and that is to keep Manitou weird.

THE BENEVOLENT SPIRIT
OF RED MOUNTAIN

I heard piano music drifting from the old crystal cottage boardinghouse that I knew was vacant, then I looked up and was startled to see a woman, who looked like Emma, peering from the attic window, smiling down at me, years after she died.

—Steve Thomas, Denver, Colorado

If you stroll down Capitol Hill late at night, you just might hear a spirited piano rhapsody drifting from the windows of the Crystal Cottage. The current owners do not own a piano, but that does not stop them from dancing to the music.

The cottage was the first house built on "Haunted Hill," in 1884, by a woman from Colorado Springs named Katie Flynn. Miss Katie, as she was known by her devoted guests, ran the sunny little cottage as a four-bedroom boardinghouse. Crystal Cottage attracted fashionable residents from all over the country, like the William Hall family, prominent farmers from Iowa; Mr. and Mrs. Showalter, ranchers from Texas; and the Burns and Stroud families, from Kansas city. The most well-known residents of the Crystal Cottage were the members of the Crawford family from Massachusetts.

Madame Crawford was a woman of charm and poise. She was a graduate of Germany's prestigious Leipzig Academy of music, and her home in Boston was the center of music circles. Perhaps her fondness for music is what inspired her oldest daughter, Emma, to become an accomplished musician. Emma showed a decided talent for music at an early age and matured into a

talented concert pianist. One review in a New York newspaper raved about her October 1887 concert in Washington Square, noting: "Emma seemed to channel all of her energy into her powerful performances, making her music seem, otherworldly to her spellbound audience."

Unfortunately, Emma's stellar career was interrupted when her tuberculosis became unmanageable. She was diagnosed with the deadly illness at the tender age of seven, and having lived in the grimy city of Boston most of her life had taken a toll on her health. The only known remedy for the lethal condition was rest, clean air and hope. Manitou Springs had become a popular destination for easterners suffering from tuberculosis The dry, fresh alpine air and the healing mineral spring waters were thought to be the only treatment for the deadly illness. In 1888, Madame Crawford, Emma and her sister, Alice, packed their bags and headed west after reading about the "Manitou Cure" in the *Boston Herald*.

While convalescing at the Crystal Cottage, Emma would often lie in bed and stare out of her attic bedroom window. Her mind dwelt long on the adventures of Indian tribes who had once roamed the hills. She was fascinated with their customs, folklore and the faith they had in their Great Spirit. She daydreamed about being well again and climbing to the summit of the mountain that she fondly referred to as "Red Chief" because it was rumored that the ghost of an Indian chief resided there. Yes, Emma believed in ghosts. In fact, her mother was a spiritualist who often hosted séances at the boardinghouse.

The three Crawford women believed that the soul, upon death, transcended to a higher plane of existence and was capable of communicating with the living. Madame Crawford was a spiritual mentor to both of her daughters and fostered their dreams and inspirations. Alice, being the youngest by six years, was fair-haired, loved to sing and dance and hoped for a stage career. Emma was more of a dark, mysterious beauty who preferred to spend time alone playing the piano or walking in the woods. The Crawford women quickly acclimated to Manitou, and they made many friends in their new home. The dry mountain climate and fresh, clean air seemed to agree with Emma especially, and her health dramatically improved. She seemed to radiate happiness as she began to fall in love with a ruggedly handsome young man named Wilhelm Hildebrandt. She had met the charming engineer while still living in Boston. The smitten bachelor followed Emma to Manitou Springs after he secured a job as chief construction engineer at the Manitou and Pikes Peak cog railroad. The joyous couple was often seen strolling about town

arm in arm down lover's lane and "taking the cure" from the various mineral springs.

One beautiful summer day, the young lovebirds took a picnic lunch to the Iron Springs Pavilion, and Wilhelm asked for Emma's hand in marriage. Although Emma was overjoyed by his proposal, she hesitated to accept, explaining that she had always felt that she would die young. However, with slight trepidation, she agreed to marry Wilhelm, with one condition: if she should die before him, he must bury her body on top of Red Mountain. She clarified that she hated cemeteries. For her, they represented great despair. She wanted to be buried high on a mountaintop in the sunshine and fresh mountain air, overlooking the little town of Manitou.

A few months later, just weeks before her wedding day, she had a strange, uncontrollable urge to climb Red Mountain. She had been warned by her physician that any strenuous activity could compromise her health, but she climbed the mountain anyway because she felt "summoned" by a spirit guide. While resting on the peak, she saw a puff of smoke swirl from the branch of an ancient pinion tree that formed into a ghostly apparition. The soaring, transparent image grew into a regal-looking Indian chief wearing ceremonial gear, complete with a full eagle feather headdress. The Indian spirit lingered a few moments before smiling at her knowingly and then fading away. Emma was convinced that the apparition was the spirit of Red Chief and believed that he had called her to the summit to bless her. Before leaving the summit, she tied her handkerchief to the branch of the ancient pinion tree and then raced down the hillside, excited to tell all who would listen about her "miracle on the mountain."

Emma stumbled home late that evening, shivering with a high fever and babbling about climbing Red Mountain and communing with an Indian spirit. The doctor was summoned, but there was little he could do to ease her suffering. She cried out for Wilhelm, and her mother tried to assure her that her fiancé would soon be there, but Emma could no longer wait for her beloved. With her last breath, the dying woman whispered, "Please implore Wilhelm to honor his promise. Remember my love to him and relay that when the Great Spirit takes him one day, I will be waiting for him on Red Chief Mountain." Then she peacefully died in her mother's arms.

After hearing the news of Emma's death, some people wondered if Emma fabricated the mysterious story about being summoned to the mount, until her next-door neighbor found a lacey, soiled white handkerchief with the initials "E.C." tied to the branch of a lonely tree on the summit of Red Mountain. The tattered handkerchief was placed on the coffin at Emma's

wake, where Madame Crawford is remembered to have said that she always knew that Emma would die young, yet she somehow felt that her daughter's memory would live through eternity.

Wilhelm was determined to honor Emma's dying wish; however, in order to legally bury Emma on the summit of Red Mountain, he had to get a deed to the land. The grief-stricken man tried but was unable to get anyone to give him a title because the mountain had been laid out with the townsite and was just Manitou lots on paper, sold by early con artists. Wilhelm did not let the legal red tape detain him. He packed a couple of burros with necessities like water, food, blankets, shovels, picks and his trusty Winchester rifle. The normally reserved Hildebrandt is recalled to have shouted over his shoulder as he left the livery, "If anyone tries to stop me from digging a grave for my darling Emma, her grave won't be the only one that I'll dig today." Legend has it that it took Wilhelm two days to burrow out a hole deep enough to accommodate the casket. The frozen earth refused to give way, and he broke the heads off three shovels and one pick before the grave was finished.

The day of the burial came, and Emma looked like a sleeping princess as she lay in her open casket. She wore the heirloom wedding gown that she had planned to marry in, and her hair was set with tiny white flowers. Fresh evergreen pine and pinion sprig crowned the small gray casket with sterling handles, and a small silver name plate with "Emma" graced the coffin lid. The funeral procession slowly crawled up Ruxton Avenue on that dreary, cold morning. The mourners waved goodbye to Emma as the pallbearers made the ascent up Red Mountain. Emma had many distinguished friends, some of whom where honored when asked to serve as pallbearers. The brave men trenched through tangled scrub oak, prickly pinion and dense pine as they marched through the rugged canyon that separates Eagle and Red Mountain.

It took twelve men working in two shifts of six men each all day long to lift the tiny gray coffin by a rope pulley system to the summit of Red Mountain. Making the trek nearly impossible was the fact that the mountain slopes are shrouded in loose red granite gravel. The pulley ropes snapped several times during the arduous journey, launching the coffin off its course and into shrubs, trees, snowbanks and gullies. Some of the men in the group grew impatient and wanted to turn back. However, Wilhelm persuaded them to persevere, as he was determined to keep his promise to his beloved Emma. It was late afternoon when they buried Emma under an ugly wind-swept pinion tree and covered her grave with large rocks.

The following excerpt is from the *Manitou Springs Journal* on December 12, 1891:

Miss Emma L. Crawford, daughter of Mrs. J.W. Crawford, passed in the higher life yesterday evening at 10:30. Funeral private...There was that in her life here...which was passing strange...a faith in the infinite unknown—the spirit life...The few who knew her here, remarked her calm unruffled mood...She was known by nearly all, as a musician of rare compassion and skill.

The funeral services over the remains of the departed were held at the family residence...Tuesday afternoon, and the attendants comprised principally the intimate friends and votaries of the faith to which the deceased was adherent. ...The entire service was unusual, but very impressive and partook not of the customary sadness at such scenes.

Among those present, was Mr. Wm. Hildebrandt, of New York, an intimate friend of the departed. To this gentleman, Miss Crawford had confided a wish to be buried on the crest of Red Mountain, which overlooks Manitou to the South. To that lone and wind swept eerie, her remains were borne on the following day and there may she rest in peace.

Shortly after Emma's death, Madame Elizabeth and Alice moved to Los Angeles, and Wilhelm, brokenhearted, moved back to Boston. Emma rested in peace for a while; her only visitors were wild animals and a few locals who claimed to have seen her spirit wondering around the mountaintop.

In 1912, the Red Mountain Incline was erected up the side of the mountain. In the course of the construction of the powerhouse and depot on the summit, the coffin of Emma Crawford was moved to the east side of the mountain, and a concrete slab with Emma's name scrawled on it was laid over her new grave site. Tourists were charged one dollar per ticket. It was a small price to pay for an exciting thrill ride and the chance to see the ghost of Emma Crawford. The cog train took ten minutes to reach the summit. But the 80 percent grade, the last one-third of the incline, was so steep that frightened riders would belt out bloodcurdling screams that could be heard all the way down the mountain. The incline was closed in 1927 after only a few short seasons, due to safety concerns.

Emma must have missed having company and decided to return to Manitou because her skeletal remains and splintered coffin washed down to the bottom of Red Mountain shortly after the incline was shut down.

Bill Crosby knew Emma Crawford when he was a child, as she was his piano instructor. He was quite fond of his teacher and even recalled going to

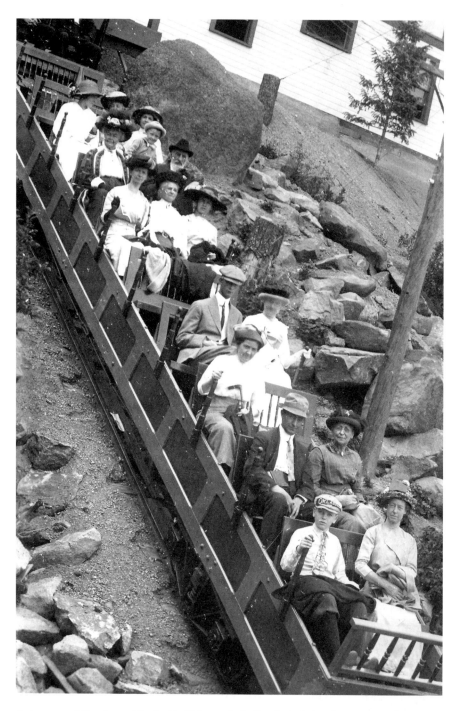

A steep one-dollar fee to ride the Red Mountain Incline included a chance to see the ghost of Emma Crawford. *Courtesy of Lois Bedore.*

her unusual funeral with his grandfather, who was one of the pallbearers. Bill was born and raised in Manitou Springs and was the town's first historian. He was interviewed by the *Gazette Telegraph* in an article called, "Is Red Mountain Haunted?" on September 24, 1947:

People wouldn't believe there was a grave up there. Nettie and I use to go up every year and put up a marker, headboard with her name and the date of her death…no one else ever went up there except for some of Emma's friends who were spiritualists, they believed the rumor that her spirit would appear on moonlight nights.

In later years, boys tramping around up there, found a skull. They took it over to Hugh D. Harper, then chief of police. Dave Banks, who was then police magistrate in Manitou, made an investigation. The party discovered human bones on the hillside and at the bottom of the canyon. They also came across the silver handles on the casket. These relics lay in city hall for 2 years. Finally, Banks and I buried the bones in Crystal Park Cemetery. We tried every way to contact any of the girl's relatives. The last we ever heard of Madame Crawford was 35 years ago. She was then in Los Angeles, and had a girl's orchestra.

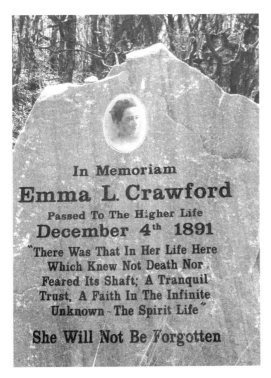

In Memoriam
Emma L. Crawford
Passed To The Higher Life
December 4ᵗʰ 1891
"There Was That In Her Life Here
Which Knew Not Death Nor
Feared Its Shaft; A Tranquil
Trust, A Faith In The Infinite
Unknown - The Spirit Life "
She Will Not Be Forgotten

Emma Crawford's memorial in Crystal Hills Cemetery. *Courtesy of Blue Moon Haunted History Tours.*

Old man Crosby, as he was known to the locals, went on to tell of how shortly after Emma's death, her mother, sister and close friends made spiritual contact with Emma during graveside séances. Over the years, many hikers have claimed to see a woman with dark, straggled hair wearing a dirty, raggedy wedding dress and wandering the summit of Red Mountain. Town folk have come to reason that the ghost perching above their rooftops on the 7,200-foot mountain is the benevolent ghost of Emma Crawford and have started to regard her as a ghost spirit that protects the little mountain village she once loved so well.

Emma Crawford died more than one hundred years ago. She may be gone, but she certainly is not forgotten. Ask any number of people on Manitou Avenue during the Emma Crawford Coffin Festival who Emma Crawford is, and they will most likely tell you that she is the patron spirit of Manitou Springs.

In 1993, John Tschannon was looking for interesting stories about Manitou Springs when he discovered the Emma Crawford story. He and the Manitou Springs Chamber of Commerce decided to pay homage to Manitou's most loveable spirit with the Emma Crawford Festival, which includes coffin races, hearse parades, ghost walks and Emma's Wake at Miramont Castle, which are held the last weekend of October. The event draws thousands of people into Manitou Springs every year and is one of the unique events that keeps Manitou weird.

THE DRAMATIC PHANTOMS
OF IRON MOUNTAIN

I stayed at Red Stone Castle when it was a bed-and-breakfast…Sure, it's a beautiful home, but that place is so haunted you couldn't pay me to live there.
—Brenda Stivers, California

A dark, blood red–colored sandstone castle stands defiantly alone on seventy-five acres at the base of Iron Mountain. The intimidating structure, overlooking the rolling hills of Manitou, is one of the town's oldest buildings and has harbored a haunting secret for more than 130 years.

Red Stone Castle was the first of several "castle homes" built in town during the 1880s. It was built on land that was formerly owned by Englishman Dr. Isaac Davis, who homesteaded the property with his wife and children in 1874. Dr. Davis was one of the founding fathers of Manitou Springs. He owned several properties in town, including the pharmacy and the Canon Avenue shoe store. He also proudly served as town mayor, chief of police, trustee, coroner, undertaker and president of the school board. With so many jobs, it's a wonder how the physician had time to father fifteen children.

In 1880, Dr. Davis's health began to rapidly decline. Some speculated that it was because of the stress of the Stringler trial. The charge of murder was brought against the physician by the husband of his deceased patient, who perished from a morphine overdose. Though the physician was exonerated of the crime, the trial took a toll on the normally robust fifty-four-year-old. He began to have severe headaches, indigestion and dizzy spells that not even the fabled magic waters of Manitou could remedy. Following the counsel of

family and friends, Dr. Davis reluctantly agreed to sell the Iron Mountain homestead to the up-and-coming Davis brothers (no relation). The warning "Buyer Beware" was boldly printed on the bottom of the land purchase agreement. No doubt the Davis brothers took the warning in stride, failing to notice the clause as a foreboding hint at the future.

The Davis brothers must have considered themselves impervious to disastrous real estate deals. Some believed that the well-liked gentlemen had a Midas touch, as every investment property they owned turned to gold. They planned on making a fortune off the Iron Mountain parcel by developing the land into an exclusive community that would be known as "Manitou Terrace Estates." The development would feature custom-built castles, for which Red Stone Castle would be the model.

Exploiting Dr. Bell and William Palmer's marketing techniques was a strategic business strategy; the Davis brothers' full-page ads espoused the wonders of Manitou Miracle Mineral Waters. The colored illustrations were featured in national publications and local newspapers in East Coast cities. In 1881, billboards depicting the virtues of the upstart mountain community were dotted throughout East Coast cities, highways and train stations. Billboards, soliciting to wealthy commuters, declared "CASTLES FOR SALE."

The determined developers envisioned a "cascade of castles" on Iron Mountain. The highly regarded Manitou Terrace would be visible from all around the valley. They planned to have an elite social club on the premises that would attract wealthy socialites from all over the world. Their dream was to make Manitou a destination for the rich and famous.

The Davis boys released investment portfolios stuffed with enticing photographs of Manitou and the surrounding region. Typical photos featured glorious color-tinted images of Pikes Peak, Garden of the Gods and Rainbow Falls, with captions that glorified Manitou Springs as the "promised land" for health seekers. Well-heeled investors from the East Coast showed great enthusiasm for the enterprising project, given the Davis brothers' sterling reputation. However, just before it was time to "seal the deal," investors suddenly dropped out of the ambitious project after discovering a well-kept secret about the Iron Mountain property: the land was haunted!

Grave sites were clustered all around the hillside when the Davis brothers acquired the land—graves of early trappers, pioneers, soldiers and vagabonds. Some had simple stone markers, while others were marked by decaying and splintered white crosses. When Dr. Isaac Davis sold the land, it was with the caveat that the brothers move the old graves in the

24

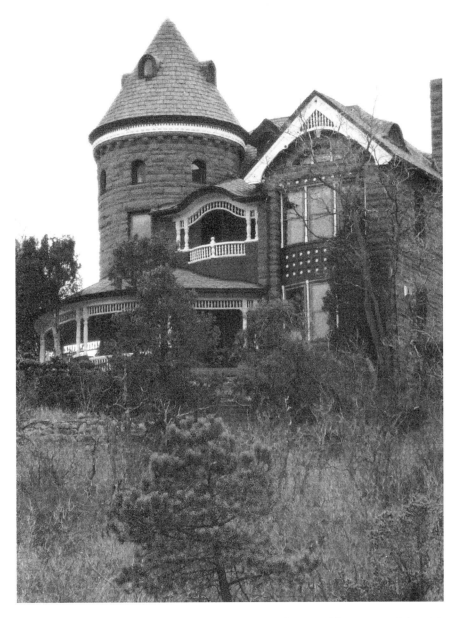

Red Stone Castle is rumored to be haunted by cemetery ghosts, a white puppy and the spirit of Alice Crawford. *Courtesy of Hannah Ruger.*

former Iron Mountain Cemetery to the new town cemetery in Crystal Hills. It took a lot of manpower to dig up rotten corpses. The remains had to be labeled, recorded, hoisted into wagons and driven over several hilltops to the new site of Crystal Hills Cemetery. Most of the ancient graves were moved; however, many were left behind, which caused people to speculate that the land was haunted.

The Manitou Terrace business venture flopped, and Red Stone Castle sat vacant for several years until Balem Hawkins and his family moved into the mansion as caretakers of the estate. Within weeks, the children began relaying frightening tales about hearing voices in the home and seeing frightening, transparent beings wandering around. The family hound became nervous and high-strung and was always digging holes in the yard and bringing home strange bones.

One morning, the children saw a shaggy white puppy sleeping beside the garden shed. One of the boys poked the tiny dog with a stick and realized that the cute little animal was dead, so they sadly buried it behind the backyard shed and respectfully covered the grave with rocks. The next afternoon, the caretaker's children were dumbfounded when they saw the very same little white dog lying by the garden shed again. The boys ran to get their mother but found, upon returning with her, that the dog was gone. A few hours later, the caretaker's wife was outside when she saw the little white canine whimpering by the garden. She bent down to pet the cute animal, and the mutt sprang at her, baring his sharp teeth. The startled woman began to slowly back away when suddenly the wrathful creature clamped his jaws around the ankle of her boot. She screamed in agony as the fangs sank deeper, as if the little beast was punishing her for crying out in pain. The caretaker, seeing the attack in progress, shot the crazed animal and rescued his wife from certain injury. A few days later, the caretaker was flabbergasted to find the freakish animal staring at him from the roof of the shed and was even more terrified when, late that night, the plaintiff howl of a dog, along with a frantic scratching sound at the back doors, echoed throughout the castle halls all night long. The next morning, the terrified Hawkins clan vacated the property at sunrise.

Over the years, it appeared that Iron Mountain reclaimed the castle as its own. Overgrown weeds and shrubs absorbed the once glorious home into the landscape, and the road to the mansion became inaccessible. Apparently, the Crawford women, who were spiritualists and former residents of Manitou, were undaunted by the menacing look of the mansion, because in 1905 they began renting the castle every summer to hold séances. The

distinguished Madame Crawford claimed to have communicated with her deceased daughter Emma on several occasions.

On December 28, 1909, the headline from the *Colorado Springs Gazette* telegraph newspaper proclaimed, "DEAD DAUGHTER PLAYS THE PIANO, SAYS MADAME: ACCOMPLISHED MUSICIAN DECLARES GIRL BURIED YEARS AGO MAKES NIGHTLY VISITS TO FORMER HOME AT FOOT OF ROCKIES":

> *Since the death of Miss Crawford nearly fifteen years ago, nightly conversations have been held between the deceased and her mother, and although awe-inspiring and almost uncanny, wonderful demonstrations have been given nevertheless. As regular as the evening shadows fall, the spirit of the dead girl, according to the assertions of her mother, appears at the Red Stone mansion at the foot of Iron Mountain, at the top of which is located the grave of Emma Crawford.*

In 1910, Alice Crawford Snow left her home and mother in Los Angeles and rented Red Stone Castle alone. The aging actress was preparing to audition for Lady Macbeth in Denver and needed time to focus on her craft. Food, firewood, fuel and other necessities were delivered to the castle on Mondays. The big iron gates at the bottom of the road to the castle were otherwise locked shut. All of her time was devoted to preparing for the highly coveted role. Her skeptical critics maintained that she was a "has-been" actress who was too old for the stellar role. However, Alice was undaunted by their opinions and was determined to prove them wrong. She woke up every morning at the crack of dawn and hiked to the tops of nearby Iron and Red Mountains. She maintained a strict beauty regime by giving herself red mud facials and mineral water enemas. The method actress began dressing in long brocade gowns of silks and satins and adorned herself with period costume jewelry and tiaras. She only spoke in iambic pentameter and insisted that all of the Monday morning delivery boys address her only as Lady Macbeth.

Eventually, friends and acquaintances stopped calling on the eccentric woman. Wilson's grocery had a hard time keeping delivery boys on staff, as none of them wanted to make the weekly drop-off to the crazy lady's castle. One time, a boy tried to drop off a delivery and was so frightened by the appearance of Alice that he just left the bags by the back door and ran down the hill without getting payment from the recluse. The kid claimed that when he hiked to the top of the hill, he saw Alice wearing nothing but a smile and dancing around a bonfire with a little white dog, shouting, "OUT, OUT, DAMN SPOT!"

Alice was convinced that the castle was haunted, and on Valentine's Day 1910, enraptured by her delusions, she pulled a .32-caliber Ivor Johnson revolver from her nightstand and shot one ghost right in the kneecap. Then she tried to set another phantom on fire. When her lawyer friend arrived that evening for an appointment, he saw smoke billowing from the castle turret and climbed through a window to get to Alice, who was found lying in bed with a bloody kneecap and her bedclothes afire. Alice Crawford was taken to Saint Francis Hospital in nearby Colorado Springs to recover from her self-inflicted wound. The *Colorado Springs Gazette Telegraph* headlined on February 23, 1910: "MENTALLY UNBALANCED: MOTHER OF WOMAN, WHO SHOT HERSELF IN KNEE, THINKS SHE WORRIES, TOO MUCH":

> *Mrs. Alice Crawford Snow of Manitou, who shot herself in the knee in what is believed by many to have been an attempt at suicide, was mentally unbalanced when she fired the shot, in the opinion of her mother, J.W. Crawford, who had recently returned from California. Madame Crawford believed that her daughter has been worrying over financial matters and other affairs until her mental condition had become serious.*

Alice had publically disgraced herself, her mother and the memory of her deceased sister, Emma. She left Manitou Springs and never returned. She died a few years later, a bitter and despondent woman. Her obituary in the *Pikes Peak Journal* read:

> *SHAKESPEAREAN ACTRESS DIES IN OBSCURITY*
> *MISS ALICE CRAWFORD SNOW WAS ONCE KNOWN COAST TO COAST*
>
> *Los Angeles May 26,*
> *Alice Crawford Snow, once a Shakespearean actress, well known from New York, to San Francisco, a favorite in the notable company of Augustan Daily's Theatre, was buried in Calvary cemetery. Among the thousands of actors and actresses, from the legitimate stage now here in the moving pictures, none knew of the passing of the former tragedienne, whose own life was full of tragedy.*
> *Mrs. Snow died Tuesday night in her home at 121 West 42nd Street. She is survived by her mother, Mrs. Crawford and her daughter, Miss Maurine Snow. She was 50 years of age.*
> *In 1910, Mrs. Snow was mysteriously shot in the leg, apparently, from her own revolver. She had returned from Denver, where she had tried in vain to get a theatrical engagement.*

The castle has had several residents over the years who have witnessed strange, paranormal activity in the mansion. Dillon was only three years old when he lived at Red Stone Castle in 1988. He would often talk about the little white ghost dog and other spirits that dwelled in his home with his classmates at Born to the Golden Mountain Montessori school in Colorado Springs, but his teachers just chalked it up to an overactive imagination.

When the home was a bed-and-breakfast, the owners claimed that the home was haunted by Alice Crawford Snow and also claimed to hear the haunting sound of piano music and a woman ranting and raving lines from *Macbeth*. Some people believe that Alice still haunts the castle, and Iron Mountain, to this very day.

Red Stone Castle has served as a B&B over the years but is now a private residence. The owners ask that you please respect their privacy by observing the "No Trespassing" sign at the foot of their driveway.

THE NAKED HITCHHIKER
OF PIKES PEAK

I had to pull my car over as the radio station went static...that's when I saw a naked woman waving her arms at me at mile marker 13. I got out of my car and asked if she needed a ride...then she disappeared before my eyes.
—Phillip Knight, San Francisco

The Pikes Peak region has been a popular tourist destination for more than one hundred years. One of the reasons visitors were drawn to the area, then and now, is because of its awe-inspiring beauty. Katherine Lee Bates penned the poem "America the Beautiful" while gazing at the prairie from the precipice of Pikes Peak. While many people may know the mountain's historical significance to the region, few are aware that the mountain's haunted reputation predates French trappers, homesteaders, prospectors and the Victorian invasion. Native American legends told stories of "lightning spirits" seen on Pikes Peak. Perhaps these mystical visions were actually produced by natural, rare weather phenomena that miners called St. Elmo's fire. Homesteaders first witnessed the "ghost lights" on the peak and speculated that the balls of fire seen bouncing around the summit had to be the souls from killed miners.

An article of the *Colorado Springs Gazette Telegraph*, February 29, 1929, reported the following:

GHOST LIGHT SEEN YESTERDAY ON PIKES PEAK
EARLY MORNING WATCHERS GET GOOD VIEW OF BEACON

[As] *that eerie ghost walked last night, many residents kept a vigilant eye focused on and near the summit of the great mountain again yesterday on the bleak whiteness of Pikes Peak, but still the peculiar light seen, last seen by W.J. Goenring, night watchman at Colorado College, between 3 and 4 O'clock in morning, remain a mystery. Hoping to catch another view of the bright spot which has been seen by at least a dozen persons, but the peak remained in darkness.*

In the 1850s, the snowcapped dome image of Pikes Peak became an icon for the "Pikes Peak or Bust Gold Rush." It has been said that more millionaires were made in that metal rush than during any other gold or silver rush in the country. It was about this time that a wagon road was built by prospectors to the summit of the illusive peak. In 1876, a weather station was built on the summit, and Sergeant John O'Keefe was the first officer assigned to work the lonely post. O'Keefe was a bachelor without children who had gained worldwide sympathy when he reported that his wife and baby had been devoured on Pikes Peak by man-eating mountain rats. A tragic photo of the funeral was printed in newspapers around the world. O'Keefe publicly apologized for the prank and claimed that he was overcome with boredom when he devised the devious plan. The summit of Pikes Peak was the perfect science lab for famed engineer Nikola Tesla. The eccentric inventor pioneered modern electrical engineering, and many of his groundbreaking discoveries were ascertained because of the experiments that he performed on the mountain.

In 1901, the first automobile climbed to the top of the majestic mountain, and in 1915, the Pikes Peak Highway was built over part of the old wagon trail. Spencer Penrose, a railroad man and wealthy Colorado Springs benefactor, donated $500,000 toward the construction of the nineteen-mile (thirty-one-kilometer) road. An auto race was held to commemorate the spectacular new highway, and the annual Pikes Peak Auto Hill Climb, the second-oldest auto race in the country, was born.

There have been several fatal car accidents on the famous mountain, especially around mile marker thirteen. The most mysterious accident is remembered not only because of its tragic circumstances, but also because ever since it happened the ghost of a nude woman has been seen hitchhiking beside the road. The peculiar apparition has become known as "Desperation Mona." Mona was seen hitchhiking on the Pikes Peak Highway long before Chicago's better-known hitchhiking phantom, "Resurrection Mary," who incidentally has never been seen naked.

It was the first day of autumn in 1932 when twenty-seven-year-old Winona "Mona" James lost control of her vehicle while driving down from the summit of Pikes Peak. The shinning new silver Studebaker that she was driving had been a wedding present from her husband, who was with her on their honeymoon when she plummeted over a 150-foot cliff. Employees at a nearby Glen Cove gift shop alerted an ambulance after Mr. James entered the building, covered in blood, and shouted, "Help me…my beautiful bride is dead!" Then he collapsed on the floor.

When the ambulance arrived at the hospital, Mr. Robert James explained to doctors that he and his new wife were en route to Alabama so that he could introduce her to his family. He told how the horrible accident had occurred— that his wife, Mona, lost control of the Studebaker on a switchback and that he was thrown from the car before it plunged off a cliff. He claimed that he walked to Glen Cove in the dark and was frightened because he lost his gun in the accident and was afraid of wild mountain lions. When doctors interrupted the man's digression with the good news that his wife was, amazingly, discovered alive, James was rendered speechless.

Robert James was released from the hospital the next morning, fortunate not to have sustained any serious injuries. He visited his bride nearly every day for three weeks until she was well enough to be brought to their rented honeymoon cottage in Manitou Springs. A few days later, a delivery boy knocked on the cabin door; when no one answered, he entered and found a gorgeous brunette naked in the bathtub—dead. Investigators reasoned that Mona had a brain hemorrhage and accidentally drowned. Curiously, an autopsy was never performed.

The headline in the *Colorado Springs Gazette Telegraph*, October 15, 1932, was as follows:

WOMAN WHO DROVE OFF PIKES PEAK HIGHWAY IS DEAD
MRS. JAMES BRIDE OF TWO MONTHS SUCCOMBS IN MANITOU

Mrs. Winona James, who was seriously injured last September 21, when she piloted an automobile over the embankment off Pikes Peak highway, died of a cerebral hemorrhage last night. Mrs. James had been discharged from Beth El Hospital about one week ago, and had taken a cottage in Manitou in which to complete her convalescence before returning home.

Mrs. James was the first visitor, ever to suffer a fatal accident, on the Pikes Peak Road, was driving a Studebaker coupe, down the road, near milepost 13, when the accident occurred. Her husband of two months,

Postcard of Glen Cove, near mile marker thirteen on Pikes Peak Highway, where the naked hitchhiking ghost is often seen.

Robert S. James, proprietor of a Los Angeles Barber shop and beauty parlor, was viewing the scenery through a telescope. Apparently she failed to see a switchback on the road, and the car went plunging down an embankment. She suffered a fractured skull and her life was despaired at the time.

With the $14,000 life insurance settlement that he received from Mona's accidental death, Mr. James bought another barbershop to add to his franchise and soon found love in the arms of his seventh wife, twenty-seven-year-old Mary Busch. It seems that the marrying man did not have much luck when it came to his wives. All but one of them—his first wife, Verna—perished shortly after taking their vows. Mary was no exception. The coroners pulled the lifeless corpse of the pretty, golden-haired beauty from the couple's backyard fish pond. Investigators reasoned that the pregnant woman had fainted and fallen into the pool; her unfortunate death was ruled an accidental drowning. Mr. Robert James collected $20,000 and bought another beauty shop. Authorities became suspicious when James wrote a letter to the El Paso County coroner four years after Mona's death and requested that the cause of demise on Mona's death

33

certificate be changed from accidental drowning to car accident. Lawmen in California were alerted, and he was swiftly arrested on suspicion of murdering his seventh wife, Mary.

The redheaded barber was soon out on bail and was planning on running for the border with his teenage niece until the police raided their bungalow and arrested James on charges of incest. Mr. Robert James was swiftly tried and sentenced to 150 years in prison. His niece, Lois Wright, was responsible for alerting authorities after her brother had died and James collected on his life insurance policy. She agreed to comply with the sting operation after learning that her uncle had taken out a life insurance policy on her, as well.

Mary's sensational murder grabbed national headlines, with captions that dubbed Robert James "Bluebeard" after the fabled wife-murdering tyrant. The spectacular five-month trial was held in Los Angeles in the summer of 1936 and was considered to be the trial of the century, long before anyone had heard of O.J. Simpson or Scott Peterson. The theatrical case had all of the components of great courtroom drama. Robert James loved the camera, though the copious photos of him make one wonder why. His bucktoothed, yellow grin, slicked-backed hair and beady eyes proved that the forty-two-year-old was a "Glamour Puss" but certainly not handsome. He was a natural showman, though, and he knew how to play an audience. He wore flashy, checkered suits, gave outspoken interviews and shamelessly flirted with female reporters, court stenographers and members of the jury. Robert James was a consummate ladies' man who wooed women with his southern charm. One witness for the prosecution stated that the recent widower had proposed to her before Mary was even buried. Another witness claimed that the lustful barber tried to seduce her at the hospital while his comatose wife Mona lay in the same room. The mounting evidence in the case, however, was purely circumstantial, and it looked like Mr. James could walk away from the murder charges, until a surprise witness for the prosecution approached the witness stand.

Mr. Charles Hope, a hot dog vendor, testified for the prosecution in exchange for a lighter sentence for his involvement in the case. Hope claimed that he had met Major Raymond Lisboan in the United States Navy and that "Robert S. James" was just an alias. Mr. Hope said that Major Ray had offered to split a large life insurance claim if he would help him murder his wife Mary and make it look like an accident.

Hope also confirmed that Robert James had confessed to killing his wife Mona four years earlier. He testified that his friend even joked about how hard she was to kill—that he had put poisonous black widow spiders in her

bed at night. Once, he even hit her on the head with a hammer and sent their new Studebaker over the side of Pikes Peak. Finally, desperate and almost penniless, he drowned her in a bathtub. The courtroom gasped as Exhibit A, a letter from Winona James, written just two weeks before the Pikes Peak car accident, was read aloud to the courtroom:

Dear sis, just a line this morning to let you know I'm pretty sick. My leg is all swollen. Something bit me while I was watering the flowers this morning. I cut my toe yesterday and am having lots of bad luck. This is old blue Monday, but my daddy will be home soon and he knows how to take good care of me. Be sure and write soon. I'll let you know how I get along.

After the letter was read, Mr. Charles Hope continued his gruesome testimony:

I agreed to help murder his wife, since the price was right. The next day, I went to a reptile farm outside of Pasadena and for $2.00 rental fee and a buck fifty deposit, I got two huge, hungry, diamond back rattle snakes, guaranteed to be lethal. Then I drove to Ray's house with the pretense of bringing a wedding gift to the newlyweds. When I arrived at the suburban La Cresenta home, Raymond drugged his wife, and threw her in the bedroom. After we got drunk, we tied Mary to the breakfast nook table, and gagged her. She was still pretty groggy, from the sleeping pills, until I shook the box of Rattlesnakes in front of her face…One of them was obviously good and agitated because the damn thing nearly jumped out of the box, and bit me. It scared Mary so bad, that she peed all over herself. Then Ray, grabbed his wife's bare foot and thrust it into the serpent's nest. The deadly snakes ravaged her, but she wouldn't die. After waiting an hour, Major Raymond impatiently untied her, grabbed Mary by the hair, drug her to the fish pond and drowned her.

The courtroom gasped in terror as the deadly assassins entered the courtroom. Two gigantic, deadly diamondback rattlers named "Lethal" and "Lightning" were coiled in a glass case marked Exhibit B. Lethal tried to strike a court stenographer sitting nearby. She shrieked, and total chaos erupted in the courtroom. One of the frightened spectators fainted and accidently knocked over the case, shattering the glass and releasing the poisonous serpents. Alarmed spectators jumped to the safety of desks, tabletops and roof rafters. Needless to say, jurors were dismissed for the remainder of the day. A headline noted, "SNAKEMAN RATTLES COURTROOM."

The "smoking gun" came toward the end of the trial from two incriminating sources. Mary's body had been exhumed, and evidence of several snakebite wounds on the right foot of the deceased confirmed the testimony of Mr. Charles Hope.

A bloodstained hammer was discovered in the trunk of Mona's junked 1932 Studebaker. James tried to plead his case by saying that he was just a poor country boy who was taught that "if a chicken pecked at you then you had to stomp it to death." When the sympathy ploy didn't work, he fired his legal team and feigned insanity, claiming that the jealous ghost of Mona was responsible for murdering his poor wife Mary. When that tactic failed, he charged that prison guards were trying to beat and starve him into confessing to the horrendous crime. On July 25, 1936, he was found guilty of brutally torturing and killing Mary.

For six years, James fought the gallows in every available court. He was even turned down twice by the United States Supreme Court. He found religion and was even baptized in the Los Angeles County jail before he was transported to San Quentin, where he became a preacher and was known as "Holy Joe of Death Row." The day before his hanging, Robert James told the press, "I'm going home, boys." He was executed on November 11, 1936, without ever being tried or convicted for killing his third wife, Mona. Many people think that she still haunts mile marker thirteen to this very day.

Desperation Mona is always seen just before dusk near mile marker thirteen. She has long, black, stringy, wet hair, and she is always naked. Ghost hunters believe that Mona is a crisis apparition who looks the way she did when she was drowned in the bathtub by her murderous husband.

An old biker known as "Pine," who worked on Pikes Peak for thirty years, had this to say:

The naked lady was a well-known sight on the mountain when I worked the Peak. I recall the summer of '73, me and the guys watched for her; one of my buddies even got a snapshot of her. She was always seen running down the mountain in her birthday suit! We called it "streaking" and joked about it on our radios. We thought she was just another doped-up hippy chick. Lots of college kids liked to go to the peak for their so-called biology homework. They liked to trip out on Bright red, white polka-dotted magic mushrooms that grow all over the south face in the springtime.

Anyway, I gave the naked lady a ride once, and I would never do it again. In fact, the experience frightened me so much that I have never picked up another hitchhiker since. It was May 4, 1973, my girlfriend's birthday.

I was the last one to drive down the peak that night. I stopped at mile marker thirteen to take a leak and light up a smoke. When I got off my bike, I looked up, and suddenly the naked lady was standing directly in front of me and was frantically waving her arms. I couldn't see her face very well because it was covered by her stringy, wet black hair. I thought it was kind of strange but wrapped my leather jacket around her anyway and helped her get onto the back of my motorcycle. I handed her a thermos of hot coffee, but she pushed it away without saying a word and refused to make eye contact.

As we rode down the mountain, I started getting scared when I could feel her cold breath on the back of my neck and her clammy hands on my shoulders. We drove in awkward silence for thirteen long miles. I can still recall gripping the steering handles so hard that my knuckles turned white. When we got to the tollbooth, the strange naked lady jumped off the bike, threw my jacket on the ground and ran naked as a jaybird back up the Pikes Peak Highway! Later that night, I found a receipt in my leather jacket from the Glen Covey gift shop stamped September 21, 1932. I brought the ticket to work the next day and showed the guys. Old Spencer knew about the legend of "Desperation Mona" and shared her tragic tale with us. I never saw her again after that, but I hear that the naked lady's ghost still haunts near mile marker thirteen to this very day.

THE RESIDUAL PHANTOM OF THE CLIFF HOUSE HOTEL

My husband Richard and I never believed in ghosts until we stayed at the historic Cliff House in Manitou Springs for our anniversary…it sure made us believers.
—Jana Botello, Colorado Springs

The Cliff House was the second hotel built in Manitou Springs in 1873, nine years after the Ruxton House. The "Inn," as it was known, started as a little watering hole for the Leadville Stagecoach Company, which used nearby Ute Pass as a main thoroughfare. When first constructed, the two-story hotel boasted fifty-six guest rooms, with rustic furnishings and tanned buffalo hides for blankets. Each floor had twenty-three guest rooms and a common bathroom. Indoor plumbing was a new concept, so even a shared bath was considered a luxury for the time.

The fate of the struggling young hotel was almost determined by the desperate strike of the insurance match. On the night of March 13, 1875, a suspicious fire started on the upper floor of the hotel. A water brigade was swiftly formed by stalwart volunteers. Within hours, the lodge was released from the wrathful grasp of the blaze. Fortunately, not a soul was injured and the damage was negligible. An investigation was conducted, but the cause of the fire was never identified. Arson was suspected, but due to lack of evidence, an arrest for a perpetrator was never possible. The Inn faced several challenges in its infancy; however, the lodge prevailed over tragedy and triumphantly grew into the grand historic hotel that you see today.

A lot of the Cliff House's success had to do with a restaurateur by the name of Edward Erastus Nichols. In 1876, he, his wife and their four young children vacationed at the struggling little lodge. The affluent E.E. Nichols was suffering from a deadly case of tuberculosis. He had traveled extensively over the years since his infliction in search of a cure, seeking advice from doctors, healers and even snake oil salesmen. His last hope was to "take the Manitou cure."

It did not take long for the ailing E.E. Nichols to be influenced by the pristine beauty of the valley and the miracle of the mineral waters. After only a few short weeks, he started gaining back his former vitality, and by the end of the summer, the invigorated entrepreneur recognized not only the health benefits of living in Manitou but also the potential to make a lucrative investment in the little upstart community. So he and his family cancelled their plans to return to the East Coast and decided to make Manitou their new home.

Nichols believed that he could transform the struggling Cliff House Hotel into a lucrative money-making establishment. The first order of business for the revived Nichols was to take over the management of the floundering hotel from the absentee Keener brothers. His wife, Anna, took care all the housekeeping responsibilities; his sons, Edward and William, were waitstaff; and his daughters, Ida and Anne, played hostesses. Within four years, he had turned the former stage stop into a respectable and profitable establishment. Nichols's business success was largely credited to the fact that he marketed the hotel to wealthy easterners, a strategy that had worked well for William Bell and his business partner, Palmer.

Many famous people have visited the Cliff House Hotel throughout its illustrious history. One of the first was Nichols's brother-in-law, Thomas Edison. In November 1915, the worldly inventor visited the recently remodeled Cliff House to see his new innovation of electricity being facilitated in the valley. Other distinguished guests over the years have included President Theodore Roosevelt, circus promoter P.T. Barnum, inventor of the automobile Henry Ford, multimillionaire J.P. Getty, robber baron Harvey Firestone and the Brad Pitt of his day, actor Rudolph Valentino. Distinguished guests came to enjoy the modern-day conveniences such as running water, electricity, fine food, spirits and the company of fellow travelers.

By 1920, Manitou Springs had tripled in size, and so had the Cliff House. Anna Nichols was a gracious hostess who endeared herself to all those around her. She threw remarkable theme parties and lawn concerts that were not only the talk of the town but of the nation as well. Big city

newspapers like the *New York News* and the *Boston Herald* often covered the social agendas of the rich and famous who summered in Manitou Springs, and they dubbed the little mountain hamlet the "Saratoga of the West." An underground tunnel that went from the hotel to the bathhouse (now known as the spa building) was added to keep the paparazzi at bay, because Anna Nichols was sensitive to her celebrated guests' need for privacy.

The Cliff House Hotel boasted a reputation for fine service and a loyal staff. Once employees were hired, they often stayed in service until the age of retirement. One loyal employee, Albert Whitehead, worked for the hotel for almost fifteen years before his career with the hotel was brought to a screeching halt. Some employees at the hotel think that Albert has never left the Cliff House, even after being murdered there nearly a hundred years ago.

On July 11, 1909, two masked bandits boldly forced entrance into the grand lobby of the Cliff House Hotel. Their pistols were already drawn when they reached the private office of the night watchman, James Morrow. One of the bandits put a gun to Morrow's head and demanded cash, checks and jewels from the company safe, while the other thug wrestled forty-three-year-old bellhop Albert T. Whitehead to the floor. Whitehead struggled against the younger, brawny hoodlum but was soon subdued, bound, gagged

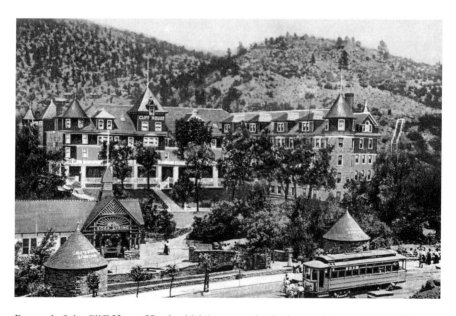

Postcard of the Cliff House Hotel, which is rumored to be haunted by a residual spirit.

and left for dead in a cold, dark storage room. The other gunman dragged Morrow down the hallway to the walk-in safe. Thinking quickly, Morrow seized a hidden Colt .45 revolver from a drawer and shot one of the robbers right through the head. Morrow was hailed as a hero and had lunch with the mayor, and soon the whole incident was forgotten.

Ironic is one way to describe what happened exactly four years later. On July 11, 1913, Albert T. Whitehead was promoted to the coveted position of night watchman at the Cliff House Hotel, a position he had longed for throughout his career. His loving wife, friends, family and hotel staff celebrated his promotion with a breakfast on the promenade. Just fifteen hours later, Albert T. Whitehead was literally running for his life. It was a very hot summer night. An inordinate amount of people were gathered on the veranda in front of the hotel. No doubt they were drinking water from the nearby Navaho and Wheeler Springs and trying to stay cool during the weeklong heat wave. Suddenly, two masked gunmen charged through a startled crowd of lingering socialites, pushed their way into Albert's office and demanded money from the safe. Whitehead must have thought that he was having a bad flashback until the gun fired, striking him from behind as he ran screaming for his life. Albert T. Whitehead had dodged a bullet once, four years earlier, but on this night he was not so lucky.

Horrified witnesses later recounted the events of that tragic evening to the local authorities. Des and Gene Spears told of how helpless they felt as they observed Whitehead running from the bandits, crying for help while blood streamed from the corner of his pursed lips and dripped from his clenched fists, before collapsing. Two days later, Albert was laid to rest in Crystal Hills Cemetery. His grieving widow and young son were received by nearly four hundred mourners. Friends and strangers came from all around the region to pay their respects. By the following summer, the tragic event had been swept under the rug. Keeping unfortunate events like armed robbery and murder out of the press, and off the lips of gossipers, was paramount to the success of a first-class hotel.

One year later, on the evening of July 11, 1914, a small crowd was seated on the outside veranda of the hotel for a moonlight serenade by the lovely and gifted soprano Mrs. Eleanor Painter. Just as Mrs. Painter reached a high crescendo, Mrs. Christine Ellis from North Carolina jumped from her wicker rocking chair and croaked out a shriek, as if she was attempting an impromptu duet with the talented songbird. The flabbergasted audience turned to look directly behind them and gasped in horror as the shadow of a man staggered out of the foyer doors and into the darkness, leaving a trail

of bloody footprints in his wake. Dr. Everett Ellis pushed aside folding chairs and dismayed bystanders in an attempt to rush after the injured intruder, only to find that he had disappeared into thin air. The local authorities were called on to hold an investigation, and frightened witnesses to the macabre performance were interviewed, but the identity of the wounded stranger remained a mystery.

Over the years, the horrific murder of the Cliff House night watchman has faded into the annals of time. However, almost every July 11, for the past ninety-seven years, an unsuspecting victim has witnessed a shadowed figure running from the hotel late at night.

Eva Spalding, a gifted psychic, was called to do a private séance on the property. Her mission was to determine who the menace was, and why he was haunting the establishment. The psychic, who was unaware of the hotel's history, surmised that the spirit specter was a past employee of the hotel who was not aware of his untimely death. The phantom was a residual spirit energy that was stuck repeating the moment before death, over and over again like a broken record. She felt that the spirit was doomed to roam the world for all eternity until he accepted the fact that he was dead and that he needed to move toward "the light."

Many people believe that the Cliff House Hotel is still haunted by former night watchman Albert T. Whitehead and that his spirit still watches over the hotel to this very day. Employees at the distinguished hotel still like to joke that perhaps Albert is still waiting around, hoping to collect on his workman's compensation claim.

Psychic Eva Spalding predicted the horrendous early morning fire on March 25, 1982. The tragic fire was accidentally started by a smoldering cigarette in room 460. The responsible party happened to be a gentleman who, ironically, had been hired by the city to "spark" the Manitou Main Street preservation campaign. The perilous firestorm ravaged the east wing of the hotel and nearly destroyed the historical landmark.

THE CRISIS APPARITION
AT THE BARKER HOUSE

My son Marcus and I met for lunch at the Barker last week. We were in the lobby
when we heard someone shout, "Give me justice"…only no one was around.
—Rita Dolbow, Colorado Springs, Colorado

There were once several grand hotels in Manitou Springs. All of them were victims of fire, but only two have survived, the Cliff House and the Barker House. Coincidentally, both historic buildings are known to be haunted by residual spirits.

The Barker House started as a ten-room boardinghouse known as the Pine Cottage, which was opened in 1872. Charles Barker bought the home in 1880. Within time, he gradually added one hundred rooms, all located on the outside of the building, allowing for plenty of light and good ventilation. The hotel expanded to 120 feet of frontage on Manitou Avenue, making the landmark Victorian building four stories, with both the east and west wings surmounted by towers. The stylish hotel had an ideal location in the heart of Manitou, which made walking to the nearby springs a delightful convenience. Every room was connected to the front office with electric bells. Modern conveniences also included steam heat and electric light. The Barker House was also the first building in the area to have a hydraulic elevator, much to the delight of the children in town.

Competition between the majestic hotels was fierce, especially between the Cliff House and the Barker House. The "Cliff," as it was casually referred to, advertised that it was located near the Navajo and Wheeler

Springs. The "Barker," not to be outdone, proclaimed that it was located directly in front of the sulfur spring.

Each hotel had regular weekly "hops," to which guests of other hotels were invited so that one could attend a different one every night of the week. A stroll from hotel to hotel on summer evenings was a pleasant form of entertainment, especially after electric streetlights were added and walkways, parks and pavilions were built around the mineral springs. The Barker's hop was held on Friday nights, usually between 9:00 p.m. and 11:00 p.m.

Mrs. Nettie Barker was a gracious hostess at these affairs, and newspapers often raved about the grand parties and the proprietor's stylish clothing.

On July 13, 1894, one newspaper accounted: "Nellie Barker wore a beautifully figured china silk trimmed dress with black velvet and white lace…Young folks at the Barker Hop flowed out of the parlors and onto the veranda, while the orchestra played and couples enjoyed dancing the Two Step, Waltz and Polka."

The Barker's famous gourmet kitchen and wine cellar was located in the back of the hotel on the first floor. It was a state-of-the-art facility, with the best equipment, and employed only the finest chefs. A typical luncheon menu would start with an appetizer, usually consommé, followed by baked mackinaw trout à la bordelaise or leg of mutton with caper sauce served with mashed potatoes and pickled beets, string beans, salad and fresh baked bread. For dessert, a variety of fruits and cheeses was offered, as were puddings, cakes, pies, cookies and ice cream, and all the meals were served with bottled Manitou mineral water or Manitou Ginger Champagne. The Barker's reputation for its culinary distinction is what distinguished the hotel from the others; in fact, its fine reputation for the best food in Colorado is what brought Governor Hogg all the way from Dallas, Texas, every summer.

On August 8, 1904, the three-hundred-pound politician was staying at the Cliff House with his wife and daughters, "Ima" Hogg and "Ura" Hogg. The governor was known not only for girth but for his odd sense of humor as well.

Governor Hogg was meeting a group of other distinguished southern gentlemen at the Barker House Hotel for a luncheon that day and would be joined by a new acquaintance, named Gus Mckemie, from Gainesville, Texas. Gus was a driven, self-made millionaire, born from immigrant stock who believed in "hard work, God, mother, country, and the great state of Texas." He was once a prominant citizen in his hometown and had served several terms on the school board. He made his fortune in cotton production and was highly regarded in the industry.

Just before the luncheon, Mckemie's wife came running into their room, whining that the headwaiter, George McCormick, had insulted her by not

allowing her into the dining room before noon. She tearfully explained that she had picked a lovely bouquet of wildflowers and wanted to place them at the head of the table as a gift for the distinguished governor of their home state. Gus assured his "little filly" that he would address the matter at once.

Gus Mckemie seemed to enjoy the stares and whispers as he and his young wife walked into the dining room arm in arm. Most of the hotel guests assumed that the old man was the freckled-faced girl's grandfather until they saw her plant a juicy kiss on his crusty mouth.

Governor Hogg thanked the couple for the alpine bouquet and then asked them to be seated as he held court over his twenty fellow mavericks. He began the meeting by telling a funny story about how he had gotten stuck in a turn sty and that the hilarious situation had made front-page news with the *Kansas City Journal* and the *Philadelphia Times*. While his captive audience listened, Gus politely dismissed himself without interrupting Governor Hogg's uproarious tales. Then he hobbled past the front desk and into the kitchen, despite protests from the hostess, dishwasher and waitstaff. Next he stepped on top of an overturned milk crate and addressed the entire kitchen staff as if he were preaching from the mount. He went on a ten-minute diatribe about cleanliness, good service and manners—especially manners. Finally he demanded to see the headwaiter, George McCormick.

George McCormick's brawny biceps were nearly twenty-two inches around, and his legs were the size of tree trunks. Friends called him "Big George" and respected the African American waiter not just because of his large stature but because of his polite and kind demeanor. Gus McKemie seemed oblivious to his enormous size when Big George stepped forward, and he instantly berated the waiter for insulting his wife. The gentle giant humbly apologized and uttered that he was just following hotel policy, but the Texan tyrant just waved his walking stick in the waiter's face and shouted, "Don't interrupt me, you damn Indian!" Apparently, not only was the old man deaf, but he was evidently blind as well.

Gus grabbed the six-foot-six waiter by the shirt and shouted in his feeble voice, "I want Texas justice!" Then he ripped the shirt sleeve right off the uniform of Big George. George tried to rebuff the old man, but he chomped down with his one tooth into the waiter's forearm. George let out a howl so loud that all of the Texans in the dining room dropped their soup spoons into their chicken consommé. Then the old Texan jumped off the milk crate and started pummeling Big George with his fists and screamed, "This is for the Alamo."

The agitated oldster, still not satisfied, grabbed his walking stick and used it to swing at the helpless waiter. Pastry chef Richard Reeves tried to

The Barker House is haunted by a former southern gentleman. *Photo by Sita Allen.*

intervene and just missed a blow to the head. The old southerner grabbed apples, bananas and oranges from a fruit bowl and threw them at anyone who came near. He ranted about everything from poor service at the hotel to the smell of the soap in the men's lavatory. When the exasperated Texan stopped to take a breath, he picked up his solid silver knobbed walking stick and used the business end to assault the waiter in the groin.

George McCormick fell to his knees in great pain as the old-timer added insult to injury by berating him further: "Why don't ya go back to China town, ya damn Yankee." Apparently, old Gus was deaf, blind and feebleminded. Then the exasperated waiter served the Texan some justice of his own by slamming a pitcher of ice water on top of his head. Blood spewed from every orifice on the old man as ice water and shattered glass sprayed all over the kitchen.

The bright crimson shower splashed the starched white aprons of kitchen staff and the poached salmon luncheon plates lined down the galley counter. The cook and the dishwasher ran out the kitchen door just as Mrs. Hannah Allen was walking in to inquire about the "Chef's Surprise"; she saw the bloody carnage, ran screaming from the hotel and was nearly hit by a passing trolley.

Governor Hogg and his constituents followed the bloody trail into the employee hallway and discovered Gus facedown in a puddle of blood and the gigantic black waiter standing over the lifeless white southern gentleman, dripping in perspiration. One Texan walked up behind the governor and shouted; "Let's have a necktie party, boys!" and another screamed, "Lynch him!"

Governor Hogg used his large frame and braced himself in the hallway to hold back the angry mob, and hotel owner Colonel Barker escorted Big George to his private apartment, where they waited for the police to arrive.

The doctor was dismayed when he walked into the Barker lobby and saw the floor bathed in a sea of blood. He later remarked to a witness that it takes most head wound victims about forty-five minutes to bleed out, while the old man bled out in and half that time.

Fortunately, justice was served, and McCormick received a fair trial and spent time in jail for the murder. However, some folks felt that the one-year sentence that Big George served for involuntary manslaughter was unfair, especially the ghost of old Gus.

John Woskowiak is a self-described atheist and skeptic who lived at the Barker House apartments for a short time in 2007. The former New Yorker said that he never believed in ghosts until he had a bizarre experience at the Barker on August 28, 2007. It was also the day that his father died. He said that after wrestling with his grief for hours, he decided to take an early morning stroll. Before leaving the building, he stopped in the lobby to check his messages, but before the connection was made, he heard someone shout, "I want justice!" on his cellphone. He claimed that it was a little unnerving but reasoned that it was just static, or his fatigue, that was causing him to hallucinate.

The next morning, John was walking through the lobby while dialing his cellphone, and a woman standing next to him warned him that cellphone service in the lobby was usually unavailable and that when you do get reception, it is static. Then she joked that some people think it is because the building is haunted by an old man who was murdered there long ago. She continued to tell him about how some people claim to see bloody footprints and handprints by the elevator and that "Gus" likes to interrupt cellphone service and television reception and ride the elevators. John was not amused by ghost stories about phantom apparitions riding the elevators and interrupting electrical and cell currents or by the paranormal being smearing blood all over his place of residence.

The next afternoon, his sister, Patricia, and her husband, Joe, arrived from Queens to help with the funeral arrangements. Patricia, a free-spirited flower

child from the '60s, claimed that while waiting for John in the Barker lobby, she heard someone whisper in her ear, "I want justice." She said, "I was so scared; it sounded like someone was sitting right next to me, but no one was there, except Joe…It freaked me out so bad I almost peed my pants."

John begrudgingly confided to his sister that he had a similar experience the night before, and Patricia surmised that maybe their father was trying to give them some kind of a message from beyond. She told John that she had heard of Manitou's reputation for being home to psychics, gypsies and white witches and that maybe they should hire one to determine if their father was trying to communicate with them.

The next day, they went to Black Cat Books on Manitou Avenue and were directed to a gifted psychic named Mariea McGill, whose office was above the store. Mariea gave John a standard twenty-minute palm and tarot card reading. John, still unimpressed with her psychic powers, handed her a twenty-dollar bill before he turned to leave. Then Mariea suddenly said, "Wait, before you go, I just got a message from your father…your father just died recently, yes? I'm getting that his name started with a 'J'…you were named after him. His name was John, but everyone called him Jack, correct? He wants you to know that he loves you, he is finally at peace…he always knew that you were the one who dented the new station wagon… also that it was not him on the phone last night…and for me to tell you that your new home, the Barker House is it?…Yes, he said to tell your new home is haunted."

John said that the experience with Mariea was mind-blowing. He emphasized that there was no way that she could have known that he had just moved into the Barker and about the eerie experience he had in the hotel lobby, about the family station wagon or that his father had recently died. He said that the experience changed his life forever, that he is now a lot more open-minded to things, and he reasons that today's science cannot explain everything. Mariea explained that if the client is too blocked or in grief or not open-minded, getting an accurate reading is more of a challenge, but all in all her batting average is pretty good.

The freakish experience motivated John to pull some strings. He told a friend about his amazing psychic reading with Mariea, and that fall, the pretty, redheaded mystic was featured in the *New York Times*. John moved out of the Barker apartment shortly thereafter. He currently lives in Colorado Springs and is writing a screenplay about his various paranormal experiences while living at the Barker House.

TERROR AT HISTORICAL RED CRAGS AND THE BRIARHURST MANOR

She was standing by the pond, a beautiful woman with long dark hair. She was wearing a white nightgown, and she was sobbing. I went to comfort her, and she disappeared before my eyes.
—Velda Dupree, Colorado Springs, Colorado

S everal historical inns and restaurants in the Pikes Peak region claim to be haunted by playful spirits. Red Crags Bed-and-Breakfast and the Briarhurst manor in Manitou Springs have made this claim for 130 years. The rumors started long before 1910, when one of the guests at Red Crags was frightened by a ghost and jumped out the third-story window of the manor.

The *Colorado Springs Gazette Telegraph* wrote about the haunted estate as far back as 1885, in the January 14 edition:

The house is tenanted, by objects whose ghostly expression and decayed features can be seen almost every night peering out into the street. The house has not been inhabited for several months. It is a gloomy place and strange noises, such as heavy bodies falling on the floor and peculiar footsteps are heard. The neighbors have been watching the house for a long time and no one has entered or departed, but every night, just before the hour of twelve the face appears at the window, lights flash and a weird procession is seen marching from room to room. There is no doubt that the house has a deep unexplained mystery, but who are the ghostly inmates holding nightly revels?

A party of young men has been organized to occupy the premises for the purpose of penetrating the mystery, which surrounds the dismal abode. Prof. Tractor, will be one of this party, believing that the mysterious visitors, are remnants of the K.O.R.N. tribe.

The haunted mansion, located in the southern part of town, is believed to be Red Crags, a historical landmark that sits alone above El Paso Boulevard and can be seen from almost any vantage point in Manitou Springs. The Victorian mansion has been painted white since the turn of the century, when it became a tuberculosis sanitarium. Before then, the rock and shingled mansion was painted a dark sepia color, which made it appear menacing in nature.

Red Crags was built by Dr. William A. Bell in 1874. Bell was one of the town's founding fathers. He was a wealthy English adventure seeker who came out west to work with General William Palmer to expand the railroad. Bell fell in love with the narrow valley beneath the slopes of majestic Pikes Peak. The bubbling springs along Fountain Creek at the foot of Ute Pass had been used by Indians for centuries. The inspired businessman envisioned the area as a prosperous resort community. He imagined spas being built around the springs that were once held sacred by the American Indians. Dr. Bell built Red Crags to attract the interests of wealthy investors. He gathered prosperous friends from England and the East Coast in the mansion and lavished them with fine food and entertainment. His hopes were to win the favor of affluent businessman who might be interested in investing in the new resort town.

One of Bell's collaborators was a young English doctor named Edwin Sully. Drs. Bell and Sully were convinced that the mineral waters of Manitou had marvelous recuperative powers. They set to work preparing a pamphlet in which they listed maladies like pneumonia; bronchial catarrh; derangement of the liver, kidneys and spleen; attacks of gout; and alcoholism—all of which could be cured by the miracle Manitou spring water. Together with Palmer, the physicians built an attractive bathhouse and a world-renowned mineral water bottling plant.

William Bell claimed that inspiration for the beautiful Red Crags mansion came from the railroad man's wife, Cara. It was well known how much Bell loved his beautiful bride, for he fondly referred to her as his "magnificent distraction." The eight-thousand-square-foot estate was exhorted for its grand beauty and European style. Bell often joked that Red Crags was the finest English country home southwest of London. The Bells did not live at

Red Crags for long because Cara became homesick for her beloved creek-side home in England. So the love-struck railroad man built her a duplicate of her childhood home a quarter mile away and only one hundred yards from Fountain Creek. Wild plum and choke cherry bushes, scrub oak and wild rosebushes reminded the young couple of the sweetbriar in their native England, thus they named their new home the Briarhurst.

In 1880, Bell turned the Red Crags into a sanitarium. A solarium and two tuberculosis porches were built on the house sometime around the turn of the century. A sophisticated call system was wired into the facility so that patients could ring directly to the nurses' station on the first floor. There were several patients who died in the home during its days as a healing center, including the niece of Senator Borah from Idaho, twenty-five-year-old Blanche Crews Smith. Her gloomy obituary in the *Colorado Springs Gazette Telegraph* noted that Mrs. Smith had moved to Manitou Springs in 1908 because she was suffering from tuberculosis. She was accompanied by her husband and eighteen-month-old son. Her husband, a musician, abandoned her and their baby when he found a job with the Ringling Brothers Circus. Blanche was estranged from her family when Mrs. C.E. Smith found the poor, sick woman and her baby dying in poverty in an abandoned shack outside of Manitou.

Mrs. Smith wired the woman's wealthy uncle and informed him about his niece and her baby. Senator Borah immediately sent her baby to live with family friends and Blanche to the exclusive Red Crags Sanitarium. Mr. Borah paid for everything during her long convalescence and gave her a generous twenty-dollar-per-week allowance, as well. She lived in the sanitarium for nearly two years before expiring from tuberculosis on April 8, 1910. The *Colorado Springs Gazette Telegraph* reported that her remains were sent to Idaho, where she was buried in the family plot, despite the fact that it was Blanche's dying wish to be buried in Colorado. Some people think that she has never left the sanitarium that she knew as her home. Some witnesses believe that it is Blanche who is seen wearing the long, white Victorian nightgown and strolling around the garden pond on warm summer evenings. William Bell's son also purportedly died in the home, as did one of the proprietors. It is not known if either of these men is associated with the haunting on the third floor of the estate. The menacing spirit on that floor was responsible for the near fatal accident of distinguished millionaire Major Walter E. Dixon of Houston, Texas.

Dixon was a wealthy Texas businessman whose southern military roots went back to the days of the Mason-Dixon line. He made his millions as

Red Crags mansion. A man was so frightened by a ghost here that he jumped out his third-story window. *Courtesy of Judy Maish.*

secretary and general manager of the Bonner Oil Company. Mr. Dixon would often visit Manitou Springs for the summer season with his high-society wife and two debutante daughters. The family most often stayed at the Cliff House Hotel, but in April 1910 he decided to rent a room on the third floor of the Red Crags estate. He claimed to have awakened at 3:30 a.m. and saw a translucent man in a long blue coat staring at him within an arm's length. The ghostly figure was so frightening to Mr. Dixon that he jumped out the window of a third-story bedroom.

The *Gazette Telegraph* reported on April 2, 1910:

Man Jumps to Ground Distance of Thirty Feet. Wealthy Texan Uninjured After the Fall. Major W.E. Dixon Evidently Crazed by Nightmare, Leaps through Window of "Haunted House."

Evidently crazed by terror, as the result of a dream, a retired millionaire merchant, of Houston, Texas, jumped from his bed, smashed through

a window, and hurled himself, through a third story window of "Red Crag's," known as the "Haunted House," near Manitou, at 3:00 o'clock yesterday morning, falling a distance of 30 feet, to the ground. The proprietor of the sanitarium and several attendants, who were aroused by Dixon's cries, found him lying in his night clothes, speechless, in terror, and seemingly, insane. Beyond severe bruises and a bad shaking up, Dixon, suffered no injuries, and one of the marvels of his strange escapade, is that he was not killed outright, or at least seriously injured. After being removed from the house, he displayed the utmost terror of those who came near him, and it required the united efforts of several men to restrain him from doing injury to himself, or someone else. He repeatedly threatened the lives of others in the room…as a result, he was taken by automobile to the county jail and placed in a straight jacket, and into a padded cell.

The newspaper article went on to describe Major Dixon as a forty-two-year-old conservative, quiet man who never smoked or drank alcohol of any kind and had no known history of mental illness. C. Clarkson, a prominent businessman and brother-in-law of Dixon's, arrived from Houston four days later to take charge of the situation and found that admitting Dixon to the Woodcroft Work Sanitarium in nearby Pueblo, Colorado, was the best solution for what he considered to be his mentally ill brother-in-law.

In the summers of 1924 and 1925, part of the mansion was occupied by an artist named Birger Sandzen. His daughter remembered that while living in the "Haunted Mansion" with her father, she would sometimes be sitting on the front porch and hear people passing by on El Paso Boulevard talking about the home being haunted.

Brett Maddox, the current owner of Red Crags, claimed that the week after moving into the home, he woke up in the middle of the night to see a little girl peering at him from the side of the bed. The same little girl was also seen by Brett's former sister-in-law when she owned Red Crags from 1988 to 1994. The Maddox family has referred to the little girl ghost as Shirley. She has been seen in several of the guest rooms, always peering over the edge of the bed. Interestingly, Shirley has been photographed on several occasions and is said to look like William Bell's youngest daughter.

Red Crags is on the National Register of Historic Places, as is the Bells' more famous home, the formerly mentioned Briarhurst, which is now a fine restaurant and is also known to be haunted by several spirits. In October 2008, the Syfy network's popular series *TAPS* (The Atlanta Paranormal Society) conducted an investigation at the Briarhurst. The special feature

Briarhurst manor is haunted by several ghosts. *Photo by Terri Marco.*

was shown on Halloween night of that year. Sandy Fitzpatrick, of Colorado Springs, watched the program and is a firm believer that the old English Tudor mansion is haunted. She and her ex-husband were caretakers of the Briarhurst manor in the 1970s and lived in an apartment on the estate.

Sandy told the author that the first day she moved in, she hung a Dixie cup dispenser over the bathroom sink, walked into the living room and heard a loud crash. She ran back to the bathroom and discovered that the dispenser was on the other side of the room, as if it had been taken off the wall and deliberately thrown there. She nailed the dispenser back on the wall and even glued the base to the wallpaper for good measure. When she got home from church the next morning, the dispenser had been ripped from the wall, leaving exposed lathe and bits of plaster everywhere—the Dixie cup dispenser was never found. She tried to dismiss the freakish incident, until her St. Bernard refused to go inside her quarters, even during a lightning storm. That's when she could no longer ignore the fact that the home was haunted.

To make matters worse, she was often left in the spooky mansion alone at night while her husband was at work. She began to realize that she was

becoming increasingly fearful as strange paranormal activity intensified around the home. She would often wake to hear the sound of a woman singing lullabies from the former nursery. Sandy, being born in Germany, recognized the old folk songs from her homeland. One time, she waited for the woman in the nursery to start singing and then flipped the light switch just in time to see the apparition of a woman by the window, rocking a baby in her arms, before she faded away. She said that the frightening occurrences seemed to become more frequent and intense as the months went by. The most terrifying experience happened when she rolled over in bed and saw a strange man lying in bed next to her. She screamed, and the man vanished into thin air. She claimed to be so frightened that she could no longer stay in the apartment; she drove her car to the nearby 7-Eleven convenience store and parked there until morning.

She moved out shortly after witnessing the paranormal intruder, and her relationship crumbled. She still blames the haunted mansion for the divorce but admits that if her first marriage had not ended she may have never met the love of her life, her husband John. Even while being interviewed for this book, Sandy admitted to being distressed, recalling the frightening experiences she had while living there, even though it was more than forty years ago. She concluded the interview by saying that she never regretted giving up the beautiful apartment and will never forget how unbelievably scary it was living in the Briarhurst manor.

HAUNTED HILL AND
MIRAMONT CASTLE MUSEUM

I had my ninth birthday party in the Queens Tea Room at Miramont. All of the photos that were taken were really strange, lots of orbs, weird streaks of light—my dad sure was spooked.
—Sheridan Hadfield, Colorado Springs, Colorado

E very castle, should have a ghost story that goes along with it—Miramont Castle has several. Legends of phantom Cheyenne Dog Soldiers roaming the Capitol Hill property have been relayed for well over one hundred years—hence it has become known by locals as "Haunted Hill."

Haunted Hill is one of the choicest properties in Manitou. The land has southern exposure, terrific views and is just a stone's throw from mineral springs and Ruxton Creek. Colonel Chivington was the original owner of the property, and ever since then the land has suffered from the fabled Chivington curse. Colonel John Chivington was a conservative Methodist missionary minister before he joined the United States Army. He was a member of a Freemason Lodge in his home state of Ohio and was an antebellum celebrity. The colonel fought most of his Civil War battles in the West. His most distinguished battle was the three-day battle at Glorieta Pass in the New Mexico territory. After the Civil War ended, Chivington began a new crusade to rid the West of the "savage" Indians. Tensions ran high as increasing numbers of miners and homesteaders flowed into Indian hunting grounds. Colonel Chivington detested the Indians and believed them to be treacherous, hostile and inferior. He believed that "the only good Indian was

a dead Indian" and often exalted the colloquialism while he spread popular propaganda about promoting Indian genocide.

In the fall of 1874 Arapahoe Indian chiefs Lefty Niwot and Little Raven, as well as Cheyenne chief Black Kettle, were promised by the U.S. government that as long as they set up a peaceful camp by Sand Creek, and flew the American flag, their people would be kept safe from U.S. soldiers. Assured by the government's promises of peace, Chief Black Kettle sent most of his warriors to hunt, leaving only a few old men, women and children in the village.

On November 28, 1874, eight hundred troops of the Colorado First Cavalry and Third Cavalry, as well as a company of First New Mexico volunteers, camped nearby Sand Creek and celebrated with a late Thanksgiving feast. The soldiers drank heavily all night long and celebrated recent victories over the hated red men. Just before dawn the next morning, Colonel Chivington declared war on the peaceful Indian village. Just before the infamous slaughter, Chivington is remembered to have said, "Damn any man who is in sympathy with the Indians."

Cherokee elder White Antelope approached the commanding officers carrying his three-year-old granddaughter in his arms. The youngster waved a white flag at the approaching troops, but the brutal soldiers ignored their signals for peace and shot them both before charging their horses over their lifeless bodies. Chief Black Kettle tried to surrender by hastily raising a white flag next to the American flag over his lodge, but to no avail. The murderous invading army was hellbent on destruction. The United States Cavalry sprayed bullets into the scattering Arapahoe and Cheyenne Indians. It is said that Chief Niwot stood in the middle of the gunfire with his arms folded, refusing to fight, believing that the white man was still his friend.

During the killings, unspeakable atrocities and mutilations were performed by the hostile soldiers. Lieutenant James Conner described the events in an affidavit dated January 20, 1875:

> *In going over the battlefield the next day, their bodies were mutilated in a most horrible manner...Sex organs of every male were cut away...I heard one soldier boast that he was going to make a tobacco pouch out of respected elder White Antelope's private parts...One young Indian squaw's reproductive organs were cut out, and displayed for exhibition on a stick... another man said that he had to cut the finger off of an Indian just to get his turquoise ring off.*

Colonel Chivington and his hired militia thugs paraded through the streets of Denver after the bloody massacre. His soldiers proudly displayed their trophies of scalps, organs, fingers and dismembered heads in saloons, brothels and gambling halls. It is said that a few of the enterprising soldiers were selling the gruesome souvenirs for profit. News of the atrocities that were committed at Sand Creek spawned an investigation. Colonel Chivington arrogantly testified before a Congressional committee a few months later that he and his men slaughtered between five hundred and six hundred Indian warriors. He boasted that because of the valiant efforts of himself and his regiment, the United States government had finally won the battle against the hostile Cheyennes.

Weeks later, Captain Soule and other witnesses came forward about the brutality of the early morning raid on the slumbering village at Sand Creek. Captain Soule planned to fully participate in a legal investigation of a soldier who was shot in the back while walking down a Denver alley—murdered in cold blood by one of Chivington's men.

Colonel John Chivington was never punished for his inhumane crimes, allegedly because he was protected by the general post–Civil War amnesty that impeded criminal charges being filed against him. The ruthless colonel

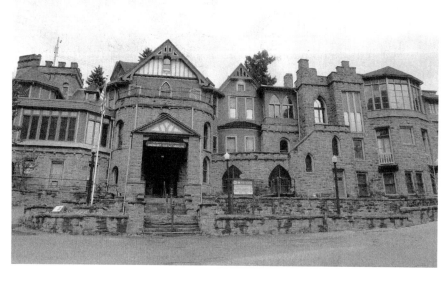

Miramont Castle is haunted by several spirits. *Courtesy of Kristina and Bryce Borglum.*

never showed remorse for his brutal acts against humanity. The humiliated soldier was ostracized from society.

Official accounts never confirmed the death of Chief Niwot at the Sand Creek Massacre. Indian legend tells that Niwot survived the attack and joined the Cheyenne Dog Soldiers, who were camped nearby Sand Creek. Ever since the massacre, witnesses have reported seeing luminous beings riding on an army of white ghost horses over the hills and down the valley of Ruxton Canyon late at night. The thundering of hooves is known to echo so loud that the reverberation rattles the rafters of nearby homes. Witnesses to the paranormal parade of Indian warriors believe that the phantoms are the spirits of Cheyenne Indian Dog Soldiers. The legendary ghost warriors are believed to be searching for Chivington so that they can avenge the deaths of their loved ones who perished by his brutal hands on the banks of Sand Creek.

Father Francolin purchased the Haunted Hill property formerly owned by Chivington in 1892. Francolin had no interest in the superstitious rumors about his newly purchased property being haunted or cursed. The wealthy Frenchman believed that the sloping hillside by a nearby stream and mineral well would be an ideal location to build his dream home, curse or no curse.

The priest was born in 1854 and named Jean Baptiste by his devout mother. Jean was the only child of a prominent, wealthy family in southern France. His birth, though a joyous occasion, caused his mother to have serious health problems that plagued her for the rest of her life. His successful father traveled frequently, as he was an international diplomat in what is now called Moscow. Because of his father's frequent absences, the young boy became very close to his invalid mother. He was sent to the best private schools in Europe, where he was a brilliant student, earning distinction among his peers as a superior artist and accomplished pianist. He was tutored in many different languages and spoke five of them fluently: French, English, Spanish, Russian and Latin. His father was no doubt disappointed when his son did not follow in his footsteps, even after he had secured a position for him at the French embassy. Jean chose to enter the priesthood, and his decision caused an even wider chasm in their already strained relationship.

Father Jean Baptiste Francolin moved to the United States in 1878. His first position was secretary to Bishop Lamy in Santa Fe. There was a lot of unrest between the Spanish Catholic clergy and the incoming French-speaking Catholic Church. Because of the friction, Father Francolin was reviled by many of the Spanish-speaking people. One of his contemptible

enemies even spiked Father Francolin's chalice with rat poison. Shortly after the murder attempt, Father Francolin moved to Manitou in 1892. His assignment was to help pastor Our Lady of Perpetual Hope Church on Ruxton Avenue. The priest was overjoyed when his lifelong stomach complaints were cured by the Manitou miracle spring water and decided to build his new home in Manitou.

Father Francolin believed that the castle should be a labor of love, built on blood, sweat, tears and divine inspiration. The fourteen-thousand-square-foot home was finished in 1895. He hired only the most talented and finest carpenters, masons, woodworkers, plumbers and electricians. Father Francolin chose to build the castle without the expertise of an architect, much to the chagrin of the Gillis brothers. Angus and Archie Gillis were the well-respected developers hired to oversee the project. The priest's convoluted masterpiece resulted in ten different architectural styles: Gothic, Moorish, English Tudor, shingle-style Queen Ann, Flemish, Venetian Ogee, domestic Elizabethan, half-timber Chateau, Romanesque and even Disney-esque. The unique castle does not sit on the edge of the mountain so much as crawl up the side of it—the front door is on the first level, and the back door is on the fourth. The mansion walls were two feet thick and cut from the local Manitou Greenstone quarry. Every one of the oddly angled rooms had a window. Few of the rooms have four corners. Some rooms have eight corners, and another room has sixteen. Suites are clustered in odd mazes connected by a string of endless staircases, hallways, tunnels and secret passages. The *Pikes Peak Journal* declared it to be the "handsomest and most artistic building in Colorado."

The eccentric architect-priest christened his castle Miramont, which in French means "look at the mountain." In June 1896, his widowed invalid mother, accompanied by five young French nuns, arrived to make the ostentatious castle her home.

February 22, 1897, was the Washington Ball at Miramont Castle. The fashionable charity event played host to the elite of Denver, Colorado Springs and Old Colorado City. More than three hundred people paid top dollar to attend the social event of a lifetime. Participants dressed the part in colonial costumes and white powder wigs and took on the personas of George and Martha Washington, Thomas Jefferson and the Abigails, to name a few. Guests were served an assortment of tasteful treats of fine smoked meats and gourmet cheeses, all of which were suited to complement the French wines imported from Francolin's family vineyard in the south of France. The extravagant social event was topped off with cherry pie, French champagne

and a fireworks display that could be seen all the way to Colorado Springs. Newspapers across the region reported shimmering accounts of the evening. One Denver newspaper reported that the castle was a treasure house of tapestries and paintings dating back to the twelfth, thirteenth and fourteenth centuries. Six months later, the priest hosted an even bigger extravaganza charity ball on August 24, 1897. More than four hundred people played a hefty entrance fee.

Suddenly the charity balls stopped. Francolin and his mother became reclusive and seldom left the confines of their lofty mountain retreat. In 1897, the Gillis brothers had to take Father Francolin to court for failure to pay other angry contractors, and investors had to put liens against Miramont. The once popular priest was now deposed by the townsfolk, as many of them speculated that Father Francolin had unscrupulous intentions when he hosted the lavish charity balls.

The straw that broke the camel's back came when the blood of an innocent girl was shed. Rumor has it that a young nun by the name of Henrietta became pregnant with the priest's child. The poor young girl was in a desperate situation, as she was far from home and could not speak English. She begged the priest to leave the priesthood and marry her. When he did not respond, the desperate teenager hanged herself from the rafters above the chapel windows. When the town citizens heard of the poor young nun's untimely demise, they raced up Capitol Hill with hot tar and burlap bags stuffed with bird feathers. They planned on having a rail party, and the priest was going to be the guest of honor. When the townspeople got to the top of the hill, the Sisters of Mercy were waiting for them, as was the town marshal. The underhanded priest narrowly escaped the angry mob by climbing through a secret tunnel. That's when contractors realized why the priest was adamant about not having an architect or making blueprints of the castle. Within weeks, his deserted mother returned to France, where she died alone. Father Francolin could not be found, and the castle was offered for sale in probate.

The Sisters of Mercy took over vacant Miramont Castle and renamed it Montcalm. The new sanitarium focused on using the "Kneipp Cure," Dr. Sebastian Kneipp's treatment focused on herbalism, exercise, nutrition and hydrotherapy. It has been said that during the great tuberculosis epidemic, the sanitarium could not accommodate all of its patients and that a tent city sprang up around its walls. Sanitary conditions were poor, and deaths were common. The castle was turned into an apartment building after the sisters sold the building in 1928. The Manitou Springs Historical Society

A ghost orb in the chapel of Miramont Castle. *Courtesy of Full Moon Explorations.*

bought the dilapidated building in 1976 and lovingly restored both its glory and its name. Historical Miramont Castle is now a museum that celebrates the rich history of Manitou Springs. Miramont Museum docents will tell you that the landmark museum is the home to several spirits and will joke that maybe the rambling fourteen-thousand-square-foot castle is haunted by lost ghosts.

Henrietta is known to haunt her former home. The poor young nun, who committed suicide in the castle, is seen wandering the hallways, headless. A mysterious shadow of a man is seen in the chapel, reciting prayers in French, Latin, Spanish and English. He is believed to be the ghost of Father Francolin, who was forced to leave his beloved home under such scandalous circumstances. The haunting image of an elderly woman, with a black veil over her face, appears in mirrors, glass reflections and even in photographs taken inside the castle. This same woman in black is often heard weeping as she glides from room to room. She is sometimes seen in the chapel sitting in the front row of pews. She appears to be reading her Bible and reciting novenas before she fades away. This ghost is believed to be the former castle director, Mother Mary John Baptist Meyers, who was on a mission in New Mexico when she was tragically killed in a train accident near Chama on August 29, 1901.

One of the most haunted areas of the castle is the gift shop on the third floor. In December 2009, Jennifer Bond, her mother and her daughter, Jamie, were visiting the castle to see it decorated in full Victorian holiday splendor. Jennifer said that as soon as she walked into the gift shop, she got the creeps; Jaime and her mother laughingly grabbed her by the hand and started to lead her down the long, narrow hallway to the doll room. Jennifer said that she has never has liked dolls; in fact, her exact words were that she hates them. She said that there is just something sinister-looking about

them, like how they stare right through you, without blinking. They were almost to the doll room when something grabbed her from behind and tripped her. She turned to look, and there was a Raggedy Ann doll, lying in the middle of the hallway. Her daughter and mother, knowing her fear of dolls, thought the incident was so hysterically funny that they couldn't stop laughing. She returned the doll to a shelf and continued to browse the quaint little shop. As she started to walk back down the same hallway, she tripped again in the exact same spot. She turned to look, and the Raggedy Ann doll was lying on the floor beneath her feet, smiling up at her. "It was really scary, because it was the only Raggedy Ann doll in the whole shop. I knew it was impossible that the doll could have followed me back down the hall and tripped me…but that was exactly what happened, and there were witnesses."

According to museum docent Margaret, the gift shop is thought to be haunted by Jenny Bouton, a seven-year-old girl who died from tuberculosis at the castle when it was used as a sanitarium. She is seen wearing a white dress or nightgown and looks so lifelike that some museum guests have even started to have conversations with the child. In 2010, the ghost girl told a museum visitor to leave, and the frightened guest happily obliged. The guest requested that her entrance fee be refunded to her, although the request was denied. Museum policy states that the admission fee is for touring the castle; seeing a ghost is free.

SÉANCE AT ONALEDGE

Heaven has no rage like love to hatred turned /
Nor hell a fury like a woman scorned.
 —William Congreve, The Mourning Bride

The family who owned the haunted Onaledge estate from 1999 to 2005 agreed to be interviewed for this book, but only if their privacy was protected. Mrs. M recalled the following story.

When I met my husband, he was CFO to a biotechnology company in Southern California. He had worked himself to the top of the executive food chain through years of working weekends without pay. He believed in the little company because he thought it held great promise for curing cancer. His interest was personal, as his first wife succumbed to cancer, leaving him with a three-year-old son and eighteen-month-old daughter. We became a family in 1992; seven years later, management changed in the company, and heads had to roll. My husband was the last of the old guard to be let go. We considered moving to Colorado, so my husband and I went to Manitou Springs to investigate. We stayed in the carriage house at the haunted Onaledge Bed-and-Breakfast. We never saw the caretaker, other guests or a ghost the entire weekend. Perhaps it was because we were hardly there, as we were swept up in the fanfare of the carnival. Everyone was wearing colorful costumes that weekend, from little kids to their parents—even dogs joined the fun. We fell in love with the

family-oriented community and great public schools and decided that we would relocate to the friendly little mountain town.

A few days after we got home, I got an e-mail saying that Onaledge was for sale. I called the owner in Texas to inquire about the property and was shocked at the low price. I was wondering what the catch was, and Milton told me that his wife, Sue, was dying and that he wanted the memories of her to die with Onaledge. He even offered to finance the home for us and said that he understood that my husband was unemployed. I wondered how he knew that, and before I could ask him for an explanation, he chuckled and said that he recognized my phone number on his caller ID and then asked if I remembered filling out the questionnaire that we left in the carriage house at Onaledge. He said that the price came with a few conditions, one being that the estate was sold all-inclusive and that, if he carried the loan, he preferred that Onaledge remain the way Sue left it. The second condition was that the mansion would only be sold as is. And the third was that the papers had to be signed within the month, because they were finalizing their estate.

Luck was with us when we sold our house in Orange County, right away and for full price; the buyer even paid cash, so there was no worry of the mortgage falling through. Everything seemed easy, except telling our adolescent children that we were moving halfway across the country. I remember my daughter cried, "We're moving into an old haunted hotel, and my life is ruined."

I remember how anxious we all were as we drove over the old stone bridge on Mayfair Avenue and around a corner to see two huge, rusted, bent iron gates that teetered from stone posts with the words "ON THE EDGE" scrolled over each of them. The four-story stone mansion was nearly covered in thick, prickly ivy, and several towering blue spruce trees hovered like wardens, making the mansion appear imprisoned by their branches. The rock 'n' roll classic "In-A-Gadda-Da-Vida" by Iron Butterfly was blaring when Ansell opened the door and told us that the inn was closed; then he realized that we were the new owners and happily gave us a tour of the estate.

It was a weird feeling walking into the six-thousand-square-foot fortresslike mansion, knowing that everything in it was ours. The home was very dark inside and smelled like burnt toast and old wood. The rich, dark Brazilian mahogany used liberally throughout the home reminded me of the old hotels I had stayed in while touring Europe. A ray of sunlight managed to squeeze into the eight-sided drawing room to expose beautiful copper light fixtures, light switches and octagon-shaped doorknobs. Even

the door hinges were made of decorative copper. Ansell said that the home was built by an Englishman and coppersmith, who built the next-door restaurant, the Craftwood Inn, as his coppersmith shop. The home was named On the Edge when his family bought it, and it wasn't long before they discovered why. He said that the mansion was haunted by several spirits and that the former owners said that they felt "on the edge" while living there. Sue had the idea to capitalize on the ghosts that haunted the mansion and named the estate the more pleasing Onaledge, opening the home as the first haunted inn in Manitou Springs.

As we walked into the nineteen- by twenty-foot rustic dining room, a giant elk trophy head glared at us from over a massive river rock fireplace, and a knight in shining armor guarded a player piano. The eclectic furnishings of antiques and modern chrome and glass furniture sat on a sea of wall-to-wall pea green shag carpet. Artwork cluttered every wall; many of the paintings looked incomplete. Ansell said that his mother was an accomplished artist. Her early paintings were paint-by-number copies of masterpieces like *The Last Supper*, the *Mona Lisa* and *Dog's Playing Poker*. As she honed her artistic talent, she later painted what she called "spirit pictures" of the ghosts that she frequently saw in the home. Many of these strange, abstract, colorful canvasses squeezed their way up the walls of the staircase and spilled into the second-floor foyer. The last painting she finished before leaving Onaledge hung over the brass bed in the master bedroom. It was a self-portrait she painted after she discovered that she had stage four cancer. The garish thirty-two- by thirty-two-inch abstract painting showed a bald, green-faced woman with a single blue teardrop dripping out of the corner of her bulging, bloodshot eyes.

On the first day we moved into Onaledge, all of the doorbells started going off. The one on the main level started ringing over and over until my husband took the batteries out. Then the doorbell on the second floor did the same thing, and he disengaged it. When the third- and fourth-floor doorbells began ringing in unison, my husband took all of the batteries out, but they continued to ring. I got really frightened, but my husband reasoned that perhaps there was a wireless system in the home of which we weren't aware. We called Ansell, and he joked that his mother was just saying welcome. Then he added that she had died the week before and quipped that she had always vowed to return to Onaledge.

At first, it was kind of fun living in a haunted house, and we used the supposed spirits as scapegoats. We jokingly blamed the ghosts for everything from spilt milk to missing socks. My five-year-old nephew, whom we called

"Moose," began talking to an imaginary friend he called Stew. Sometimes I would stand outside the guest room door and just listen to him chatter away. One day I asked him about his imaginary friend, and he described a woman "with big yellow hair and shiny rings." I said, "I want to know what Stew, your invisible friend, looks like to you, because I can't see him." Again he described the same woman, adding, "She smells pretty and likes to color with me, and her name is Stew." Moose had a speech impediment, so I asked him if he meant to pronounce "Sue." And he said, "*Yes*, my friend, Stew." That's when I got really spooked. Ansell had shown me a picture of his attractive, stylish-looking mother, and Moose described her perfectly. KKTV news caught wind of the strange story and conducted an interview at Onaledge with Moose and Aleea, Sue's granddaughter. Aleea grew up in the haunted home and explained that her grandmother believed that Onaledge was haunted by friendly Indian spirits and that she had names for the different colored balls of light floating in various rooms throughout the mansion. During the phenomenal interview, one "ghost orb" was caught on camera.

At least the home seemed to be haunted by happy spirits. Pennies were often found in the most unusual places. An antique copper magnifying glass went missing for a while, only to turn up a couple of weeks later in the refrigerator. I noticed that the curtains often pulled open by themselves, especially in Sue's sewing room. I asked my daughter if she believed in ghosts, and she pondered for a moment and then asked, "What's the difference between ghosts and angels?" I didn't have an answer. It made me wonder, though, and I thought that maybe Sue and the other spirits were just the harmless guardian angels of Onaledge.

The home needed many repairs, as it had been neglected for quite some time. Sue must not have liked all of the changes being made. One carpenter from B&J Construction claimed that he saw a beautiful woman with blond hair who walked right by him and disappeared. He became so frightened by the apparition that he left the job, refusing to return, even for the tools that he left behind. Jarrod Zumwalt and his brother, Noah, are self-employed carpenters who said that they were alone in the basement and kept losing their tools, as if someone was deliberately hiding them. Sometimes they were found in the trash but more often in the toilet. It wasn't long before the ghosts got to me, too. The ghosts of yesterdays and memories of Sue. We had lived in the house for several months, yet it still didn't feel like *our* home. I realized I was becoming jealous of a ghost. I'm an artist, and I really wanted to hang my own paintings. Plus, I had always dreamed of restoring a historical home and furnishing it in antiques. I called Ansell and told him

how I felt and was greatly relieved when he assured me that Milton would likely never return to Onaledge, so I should decorate the home as I pleased.

So I decided to have an estate sale and sold almost everything except for the garish self-portrait of Sue. After the sale, I taped a "Free" sign on it and put it by the front gates, thinking someone could at least reuse the canvas. A week later, it was still staring out at the street, and I noticed someone had thrown eggs at the menacing-looking portrait. I stuck it by the trash, but it was refused. I didn't know what to do with it. I thought of taking it to Goodwill, but the damn thing wouldn't even fit in my car. Finally, I hacked it up with an axe and burned it in the stone incinerator in the backyard. That was absolutely the biggest mistake I ever made in my life!

The next day, a ten-foot geyser of raw sewage shot into the air from a manhole in front of our house, and the embarrassing, foul odor forced neighbors to close their windows in the late summer heat wave. Even the Craft Wood Inn restaurant owners next door called to complain that they were losing customers due to the foul odor coming from our house. City crews discovered that the break was on our property. We spent thousands of dollars to bring in a backhoe and portable toilets and to replace the main sewage line. That was just the beginning of a series of serious plumbing problems on which we spent a small fortune. Then we had an electrical fire in the carriage house, and on and on and on. I remember saying to my husband that hopefully we will look back and laugh about all of this one day, and he said, "Yes, but will it be a hardy chuckle, or something more demented?" Then I remember joking that no wonder the former owners named the house On the Edge.

The paranormal activity in the home became frequent and hostile, and we no longer laughed at what we had once joked about. One night, Moose walked into our bedroom at about 2:00 a.m. and woke me up. I asked him if he was sick, and he whispered in my ear, "Stew wants you out of her house." Then he turned and shuffled back to his room. I think he must have been sleepwalking because the next morning he didn't remember a thing. A few weeks later, Moose wandered into our bedroom early in the morning, crying. I turned on the light, and he was holding a pair of sharp scissors and was covered in blood and scratch marks. I screamed and asked him what happened. He looked like he was asleep and mumbled, "Stew doesn't like cats." I picked him up, took him to his room and discovered that he had cut one of our kitten's ears off.

I was beginning to feel unwelcome in my own home, and I blamed the vibes on the spirits of Onaledge. I used to curse the ghosts and shout that it was my house, not theirs, but it only seemed to make matters worse. I decided that I needed some professional help, so I called Full Moon Explorations

Strange lights photographed during a séance at Onaledge. *Photo by Kameron Moding.*

in Denver. I told the members everything I knew about the history of the house, but that was all. About a dozen people did an all-night investigation in the home and captured about three hundred photos of orbs, streaks of light and ghost shadows. They also recorded several EVP recordings. (You can see and hear the evidence they collected by visiting their website.)

The midnight séance in the carriage house that night is what finally convinced me that we needed to sell Onaledge. There were several people present when the Ouija board spelled out "F*CK YOU" and then flew off the table and splintered into pieces after crashing against the stone wall. A digital voice recording during the séance revealed a man's voice shouting, "F*CK YOU" at the same moment that the planchette spelled out the vulgar phrase on the Ouija board. I have never been so scared in my life. In retrospect, I can see that it was a moot point engaging in a battle of wills with the spirits at Onaledge. I should have been smart and befriended them, like Sue did.

No one wants to be where they are not welcome. We sold Onaledge in 2005 to the Maddox family, also from Texas, just like Sue and Milton were. If I could say anything to Sue, it would be, "Good riddance." I was never so happy in my life as the day we left Onaledge.

Onaledge is now part of a trio of distinguished bed-and-breakfasts, owned by the Maddox clan, neighboring Rockledge and Red Crags being the other two.

HAUNTED MIDLAND
RAILROAD TUNNELS

*We saw the glowing red ball of light float from the mouth of the Old Widow
Maker tunnel. We knew right away that we were having an experience that was
purely supernatural in nature.*

—Rhonda Jones, Missouri

The old wagon roads and railroad tunnels of the Pikes Peak region
have been known to be haunted for well over a century. Phantom's
Canyon Road, an old stage road between Victor and Canyon City, was
given that name for a reason. Old Irish legends about Tommy Knockers
haunting mines and railroad tunnels were some of the first ghost stories
to be told in the region. Tommy Knockers were spirits of miners who
died in mining accidents. They were believed to help prospectors find
ore and warned them of impending danger by knocking rapidly on
the tunnel walls. During the "Pikes Peak or Bust Gold Rush" in 1870,
thousands of hopeful miners flooded into the state. Wagon roads from
the Front Range crawled over the Rocky Mountains and into nearby
gold mining camps of Victor, Cripple Creek and Leadville. These deadly
thoroughfares were laden with peril: unsafe roads, inclement weather,
wild animals and ruthless highwaymen.

When the railroads came into the region, they adopted some of the old
stage lines as their own. The ill-fated railroad line known as the Midland was
built on the old Leadville stage line. The route cut a sharp passage through
Ute Pass, continued to Hayden Divide and rolled across expansive South

Park to Leadville and then over the Continental Divide. Some people believe that the Midland line was jinxed from the beginning. Construction began on both sides of the Hagerman tunnel in 1886. However, plans were abruptly halted when silver was discovered, and several workers on both sides of the mountain "laid claim" to the mine. Battles between the workers ensued, leaving the snow stained with their blood. The Blizzard of 1899 killed forty-nine people and nearly bankrupted the struggling railroad when an avalanche arrested the Midland for seventy-seven days. There were thirteen deadly tunnels that were dynamited to make way for the Midland line. The railroad tunnel's hazardous curves and blind corners became legendary. Veteran engineers dubbed the dangerous line of tunnels "the deadly 13." Special distinction was given to the most dangerous tunnel, which was given the justified title of the "Widow Maker." The Midland Railroad soon became known as one of the most deadly set of rails in the country.

The *Colorado Springs Gazette Telegraph* was prompt about reporting serious accidents on the railroads. On February 14, 1922, the newspaper reported about one of the deadliest railroad accidents in regional history. It happened in tunnel no. 4 just outside of Cripple Creek. Locals still refer to the tragic event as "the 1922 Valentine's Day Massacre." Innocent lives were lost, all because of the negligence of wealthy rancher Thomas Wales. Several of the rancher's prized cattle had escaped from his barn and taken refuge from the elements in railroad tunnel no. 4. Unaware of the present danger, the railroad engineer plowed the locomotive at full speed through the deepening snow and into the dark tunnel. Five innocent lives were lost in the horrific, bloody tragedy. An inquest was held, and Wales testified that he was at fault for leaving his barn door open and agreed to pay restitution for the damages. However, before leaving the courthouse, he boasted that the tenderized beef that resulted from the assault was the best beef he had ever eaten. Fortunately, the only blood spilled on the tracks that Valentine's Day was bovine.

Cows were a serious problem for the railroads. One famous accident involving a cow occurred when the heifer inadvertently flipped the switch on the C&R route, causing a train to jump the tracks. It happened in 1909 when an engineer plowed into a cow near Falcon, Colorado. The collision between machine and beast resulted in the cow being catapulted fifty feet into the air and then thrown down onto the switch bar with such force that the guard gate flew open, derailing the engine and five passenger cars behind it. Fortunately, no one was injured. There are no known hauntings from the murdered cows in Falcon or Cripple Creek.

The most frightening ghost stories about the haunted rails and the Pikes Peak region are about the formerly mentioned Midland Railroad's Widow Maker tunnel. The paranormal hot spot can be seen from Highway 24 between Manitou Springs and Cascade on the old Midland Railroad ridge. Investigating the tunnel can be a dangerous endeavor, as crossing a stream and hiking up a steep graveled hillside are necessary. Ghost hunters in the know have held expeditions to the haunted location for generations. The Widow Maker is easily distinguished from the other four tunnels on the ridge as it is the largest and the only one that is filled with complete darkness. Inside the cavern are hundreds of vampire bats clinging to the ceiling and walls, and they squeal in unison when a presence other than their own is detected. It is believed to be haunted by the ghost of a deranged derelict who escaped from two different insane asylums before his mangled, decayed corpse was found there. The hermit lived and died in the Widow Maker. Some folks think that he still resides there, even in death. His apparition has been seen along the tunnels of the Midland line for nearly a century. The first indication of his ghostly presence is the soft glow of a red light and the sound of a man whistling. The specter walks with a limp and wears dark overalls. His face has never been seen. It is a bad idea to visit the ghost at the Widow Maker tunnel, not only because the hike is dangerous, but also because seeing the apparition swinging his red warning lantern is thought to be a harbinger of death.

The legend begins with a man named Michael Ryan. The fifty-year-old educated railroad engineer incurred a head injury in an accident near Cripple Creek in 1895. It was said that Ryan won a large $10,000 settlement for his grievance before he left the region. Ryan returned to the Pikes Peak area in 1900. He lived in an abandoned shack by the mouth of the Widow Maker tunnel for several years. The hut was furnished with found objects. One of his prized possessions was a railroad signal lantern that he carried with him night and day. Locals normally kept their distance from the hermit, unless they needed to walk through the Widow Maker. Most hikers agreed to pay the toll the bum charged for using the tunnel; other people were frightened by his lunacy and completed avoided the area. Many people believed Michael Ryan's stories about his former life. He claimed to have associated with many influential people, including the railroad developer Jay Gould and other well-known wealthy businessmen of the day. He also spoke several different languages, sometimes all at the same time. His most favorite expression was said to be, "I use to be a slave man, but now I'm a cave man"—only he preferred to say it in Latin.

There are several intriguing articles written about the enigmatic man. On December 11, 1904, the *Gazette Telegraph* reported:

QUEER LIFE OF HERMIT WHO SAYS HE KNEW JAY GOULD

Living alone, in a tumbled down shack, in the mouth of tunnel number 3, near the iron spring, in Manitou, Michael Ryan, an aged hermit, is a mystery to the neighborhood…Ryan talks at times to persons with whom he has become acquainted, but his conversation drifts to Wall street, the stock pits of Chicago and New York, and he speaks with familiarity about his old friend, Jay Gould. His talk would indicate a relationship with such men as Schwab, Hill, Belmont and Morgan. The Hermit is highly educated in Latin, and speaks German, French, Italian and English, fluently. He will not beg, or receive alms, although he lives in squalor and cooks his meals in an old Iron kettle outdoors. Whether demented or not no one seems to know, but he will often climb a tree and bark like a squirrel and when tired out, returns to his shack and goes to sleep upon a bed of leaves and torn blankets.

On February 3, 1902, the *Gazette Telegraph* reported that Michael Ryan had disappeared. The article went on to say that "Manitou's entire police force was out searching for the hermit of Manitou…Children, who were out of school on holiday signed up to join search parties of concerned neighbors, who feared the mentally ill old man might freeze to death in the sub zero weather."

A few weeks later, Michael Ryan returned to his shabby shelter. In his almost unintelligible way of speaking, he made his neighbors understand that he had wandered up the cog road when a cloud settled about him and he became lost. He claimed to have been attacked by coyotes but staved off the hungry animals by cutting off three of his own toes and throwing them to the wild beasts. The frail old man was convinced that the desperate act had saved his life and deadpanned that the digits on his left foot had to go anyway, as they had developed gangrene from frostbite. As winter turned to spring, reports of the mentally ill old-timer becoming increasingly deranged worried some of his fellow citizens.

The headline and article in the *Colorado Springs Gazette*, April 25, 1905, read as follows:

HERMITT RESENTED INTRUSION WITH BUCKETFUL OF WATER. PROFESSOR M.C. GILE OF COLORADO COLLEGE AND MR. BARRY WERE GREETED BY A SHOWER OF STONES BY THE RECLUSE OF MANITOU

Michael Ryan, the queer old character, who is familiarly known as the hermit of Manitou, has at last come to grief. It all happened yesterday afternoon. Professor M.C. Gile, of Colorado College, and Mr. Barry, a paymaster for General Palmer, were starting up the hill to Crystal Park when without warning, the old hermit ran out of his cabin, which is near the Midland Railroad trestle and at the foot of the trail. He evidently objected to them being so close his place of abode, and though they had in no way molested him he waved preliminaries and doused Mr. Barry, who was in the lead, with a pan full of water he was carrying. Not satisfied with this, he struck Mr. Barry with a heavy blow on the wrist with the pan. Then he began throwing a fusillade of rocks upon the mountain climbers. Seeing that the old man was not in a playful mood, they beat a retreat. Reaching a telephone they endeavored to call the Manitou Police force, but failing to locate the stalwart guardian of the law, who was absent in Colorado Springs, they notified the Sheriff's office. Ryan did not look with favor upon the deputy sheriff, and neither was he awed by display of the silver star on the officer's vest. He barricaded the door and it was only after a lively scuffle, that he was amenable to reason. The old hermit was not placed in custody today, but will be examined by county official Richardson tomorrow, to ascertain his sanity. It seems that he has been in the habit of greeting wayfarers in this manner for some time, but this was the first time a formal complaint has been lodged against him.

The case was presented to Judge Robert Kerr and a jury in county court. The most convincing testimony came from Professor M.C. Gile, who gave a graphic account of the case. County Physician Richardson's findings were that Ryan had escaped from an insane asylum in Minnesota before returning to Colorado in 1900. The jury found that the defendant, Michael Ryan, was of unsound mind. Henceforth, Judge Kerr ordered that the defendant be placed in the custody of Woodcraft Work Asylum in Pueblo, Colorado. The "Hermit of Manitou" resided at Woodcraft for only nine months before the accomplished escape artist vacated his padded cell.

In 1923, the shredded remains of an old hermit were discovered in the Widow Maker tunnel. It was difficult to determine the identity of the remains, as the state of decay indicated that the death had transpired months earlier. The only clues to the man's identity and cause of his unfortunate demise was that he was missing three toes from his left foot and that a railroad warning lamp was shattered on the ground next to the skeletal remains. Michael Ryan and his warning lantern were reburied where he was found, as he

Eerie apparition photographed while dowsing in the Widow Maker tunnel. *Courtesy of Lynn Ruais.*

would have wanted. Many people believe that the "Hermit of Manitou" still haunts the Midland tunnels to this very day.

Matt Bond and brothers, Devin and Darin Waters, backpacked to the old Midland Railroad ridge on Intemann Trail to observe the natural meteorite showers in August 1985. After campfire tales, hamburgers and a twelve-pack of beer, the young men took to their bedrolls. About three o'clock in the morning, just as the teens were drifting off to sleep, they noticed a glowing red light emerging from the nearby railroad tunnel. As the mysterious light drew closer, the trio realized that the red glow was produced from a lantern that was being held by a man who walked with a limp. They pretended to be sleeping as they peeked from beneath their blankets and observed the mysterious red lantern getting closer. They could hear the approaching stranger's heavy, rattled breathing getting nearer as they lay, defenseless and paralyzed with fear. The unwelcome stranger halted abruptly when he reached the boys' camp. Then he rested his lantern on the ground just inches from their sleeping bags. He pulled a small weathered black book from his tattered coat pocket and stood solemnly over the bewildered boys for what seemed like eternity before he spoke. He recited something in Latin with a

deep, resonating voice that made the boys quiver with unabated fear. Then he stuffed the book back into his pocket and slowly limped off into the early morning mist, whistling as the glowing red warning lantern swung by his side. The next morning, the boys laughed about the puzzling experience and credited their shared hallucination to fatigue.

That afternoon, Devin gave Matt a ride home from work in his classic 1969 Shelby Fastback Mustang. At about 3:00 p.m., the midnight blue Ford drifted around the corner of Hancock and Fillmore, barreled over the sidewalk and bushes and slammed into an industrial lamppost at the Templeton Gap Sod Farm. The impact was so loud that neighbors ran from their homes and drivers leapt from their cars to see what had caused the commotion. The classic car had flipped on its top during the impact and was wrapped so tightly around the light pole that it seemed impossible for any passengers to have survived. When the coroner arrived to pull the bodies from the wreckage, he was surprised to find that the young men were still alive. The victims were transported to Penrose Hospital, where they both regained consciousness a short time later. Neither one of the teenagers could recall the events that had transpired before the horrific accident but considered themselves to be fortunate to have nearly escaped from the jaws of death.

Ironically, early the next morning, Darin Waters was driving a *Colorado Springs Gazette Telegraph* delivery van near Fountain Boulevard and Hancock when he also experienced a mysterious accident on a big lawn. While driving near the intersection of Hancock and Fountain Boulevard, his van jumped the curb and plowed into three mature oak trees before coming to a complete stop on the lawn of Evergreen Mortuary. Darin amazingly survived the harrowing experience uninjured and unaware as to why the accident had happened.

Matt, Devin and Darin are middle-aged men now but will never forget their strange experience that night at the Widow Maker tunnel or the mysterious accidents that followed. All three men concur that the ghostly stranger had something to do with their peculiar accidents and wonder if the mysterious phantom saved them from the certain perils of death or if he was the cause of the two potentially fatal car accidents? One thing they do agree on is that they will never return to the Widow Maker tunnel and strongly advise anyone thinking of doing so to reconsider.

MANITOU'S DR. FRANKENSTEIN AND HIS CEMETERY MUMMY

We went to Crystal Hills Cemetery that night on a dare. I never believed the stories of the Manitou mummy until I saw him with my own eyes.
—Darell Smith, Colorado Springs, Colorado

There are many spooky old historic cemeteries scattered about the Pikes Peak region. However, none of them could be more frightening than the Crystal Hills Cemetery in Manitou Springs. The ancient graveyard is older than anyone really knows, as it was used as an Indian burial ground long before the Victorians laid claim to the valley. Several American Indian artifacts such as cradle boards, beads and arrowheads were found when graves were dug on the property.

Native Americans are taught that a person's spirit remains on earth until their bones disintegrate. Therefore, burial grounds are especially revered in their culture. It is important, they believe, not to disturb the deceased remains because doing so can cause the spirit to become restless and prevent the life force from moving toward the Great Spirit.

The Indian burial ground was known as "Crystal City" by early prospectors, who were looking for gold but instead found a treasure-trove of crystal and various minerals. Beds of smoky quartz crystals, purple amazonite and yellow topaz were in abundance. The hillside was an ideal spot to put the town cemetery but was not the first choice. The Iron Mountain Cemetery earned that distinction. It was established in the 1850s for early French trappers, explorers and pioneers. Most of the graves

were relocated to the new Crystal Hills Cemetery on Plainview Place. The isolated cemetery houses the remains of some of the town's most illustrious citizens. Founding fathers Jerome Wheeler and Dr. Creighton, as well as Dr. Isaac Davis and his extensive clan, are all buried in its keep.

The scenic land is a natural fortress. It is bordered by mountains on three sides, while the north side of the property sweeps down the hillside, exposing picturesque views extending all the way to the Garden of the Gods Park. Cottonwood and evergreen trees are abundant, and bears, deer and other wildlife are just about the only visitors to the secluded grounds. The wrought-iron gates outside the forbidding graveyard are rumored to have been put there to keep someone from leaving the property, rather than for keeping trespassers out.

Speculation about Crystal Hills Cemetery being haunted began when newspapers headlined: "MUMMY ESCAPES FROM CRYSTAL HILLS CEMETERY." Rumors of the escaped mummy fueled speculation that the new cemetery was haunted. The astonishing news was heralded because a maintenance crew discovered that the burial site of a corpse had been disrupted. Looking into

A hearse photographed in Crystal Hills Cemetery. *Courtesy of Jason Lopez.*

the vacant grave, they found that the cadaver had vanished. The discovery caused alarm among the citizens of the small mountain community of Manitou. Neighbors began locking their doors and windows out of fear that the living dead man was wandering the hillsides. Rumors of the resurrected man spread all the way to Old Towne and Colorado Springs.

The legend of the escaped mummy began in Old Town, which is now known as Old Colorado City. The blue-collar railroad and mining hub was located halfway between Manitou and Colorado Springs. The railroad men and miners from the Golden Cycle Mill frequented the many blue-collar saloons, gambling halls and a few notable whorehouses that were located in the red-light district of Old Town. Cheating in poker and games of chance was common, and tempers would flare. Most of the time these altercations escalated to violence. It was the wild, wild West, and gunfights were commonplace, as were battles with knives, clubs, fists and beer bottles.

Thirty-five-year-old Thomas James O'Neel was a redheaded, bucktoothed Irishman with a bad temper and a propensity toward violence. He was known to conceal a six-inch knife in his boot, which earned him the menacing nickname of Jack Knife Tom. The Irishman was known as a mean, cheating drunk who had once slit the throat of a man because the man made the mistake of winning Tom's rent money in a game of cards. Witnesses to the macabre scene claimed that wicked Jack Knife Tom laughed while his helpless victim bled dry on a dirt road.

One fateful day, Jack Knife Tom met his match when he cheated the wrong miner out of his hard-earned pay. Tom was asked to step outside and was shot dead on the spot. Lesson? You don't bring a knife to a gunfight. Jack Knife Tom was kept on ice for the standard three-day holding period while an attempt was made to locate friends or family members of the deceased. When no one stepped forward, El Paso county coroner Dr. Isaac Davis took the dead man into custody.

Dr. Isaac Davis was a founding father of Manitou Springs who lived above his drugstore with his wife and their fifteen children. Davis held positions from undertaker to chief of police. He was also a popular mayor for several terms and the town trustee. Despite all of Dr. Davis's civil and charitable work, whispers of the man being a demented mad scientist sadly followed him until the end of his days. Dr. Davis was also compared to the fictional Dr. Frankenstein. The similarities between the two mad scientists were hard to ignore, as both doctors liked to demonstrate their art on freshly acquired cadavers, and both of them turned human corpses into monsters.

Dr. Davis believed that the corpse of Jack Knife Tom would make the perfect specimen for his new pet project. The doctor called it a "pet project" because it started with pets—his pets.

Spot was Dr. Davis's best friend. The wiener dog could hunt, fish, run and swim better than any man he had ever known. The doctor and "his Spot" were constant companions. Davis felt horrible when he let the hound outside for a potty break and the dog didn't come back. He whistled for his loyal friend several times during the subzero arctic winter storms, but the pup did not return.

Dr. Davis found Spot the next morning frozen to a fence, with his back leg still hiked in midair. The distraught doctor pried the pooch off the wooden post and attempted to revive his frozen body by the fireside. However, when his loyal companion failed to respond, the devastated doctor could not bear the thought of being without his hapless pooch. So during his state of grief, he devised a plan to make his loyal friend immortal. Chemicals were at his disposal, and after only two hours of processing, Spot became pet project no. 1 in a jar labeled "OPPS. Spot 1-20-1880."

Pickles, his wife's loudmouthed parrot, was next to be "jarred." Pickles had had it coming for a long time. The brazen bird resided at the Davis shoe store and would inadvertently offend the customers by screeching, "Stink alert…pretty boy…fat feet…peeeeeeuuuuu."

Dr. Davis's pet projects grew to include domestic and nondomestic animals. Mice, snakes and rabbits were common. The various species were pickled in jars and labeled as to their various contents, date and specific embalming recipe. Within time, the good doctor tired of animals and began harvesting human organs from live donors. Dr. Davis was thrilled beyond belief when he delivered Mrs. Whitehurst's sixth child, a girl after she had given birth to five precocious boys. On that joyous occasion, he proudly announced, "Congratulations, Mrs. Whitehurst. You now have the beautiful baby girl that you have longed for. She is healthy, a nice weight and she has strong lungs. She does, however have an extra ear, but that can be remedied, and at no extra charge."

The doctor's favorite hobby was collecting pickled body parts of animal and human organs and appendages. His unusual collection became so large that it expanded from the confines of the scientist's laboratory. His wife often complained about what a fright it was to find glass jars with floating body parts in them hidden in kitchen cupboards, chamber drawers and closets. She often pleaded with her husband to find more suitable accommodations

A hut in Crystal Hills Cemetery where the mummy of Jack Knife Tom is still seen today. *Courtesy of Elizabeth Clinger.*

for his menagerie of monstrosities. Finally, the eccentric physician found the perfect location to conduct his scientific experiments.

The obvious place to build his secret chamber of horrors was the remote Crystal Hills Cemetery. Dr. Davis donated the cemetery land to the city, so it seemed reasonable to him that he could build his new laboratory there. He built a beautiful stone house under several expansive shade trees. The small rock home had to be kept cool and without much variation in temperature so that the preserved animals and human organs would not decompose in the pickling jars. A fireplace was added to warm the hut during the winter. Wooden shelves and a small desk were installed so that Dr. Davis could work there without being disturbed by his large, extended household. Davis enjoyed the solitude of the stone hut in Crystal Hills Cemetery. He would often bring a picnic lunch to eat as he worked on his projects. The doctor also liked to relax in his hammock outside his laboratory and smoke a corncob pipe while reading science periodicals.

Davis filled the stone abode with an impressive collection of preserved oddities. He had several scalped hairpieces, a few birds' nests and a collection of crystals, arrowheads and vacated birds eggs. The most cherished part of his collection were the many glass jars that contained unusual artifacts, like the two-headed snake, a six-legged kitten and a stillborn human fetus. All of the specimens floated in glass jars, filled with his secret preservation formula, and were sealed with clear canning wax.

Dr. Davis did not have a jar big enough for Tom O'Neel. After contemplating the dilemma, Davis began to realize that he could possibly mummify an entire human corpse. He began to consider how he could alter the pickling recipe to make the formula viable for human mummification. Next, he took Tom to his stone hut laboratory in Crystal Hills Cemetery and placed Tom's body in a galvanized bathtub filled with chipped ice, menthol, salts and formaldehyde—the rest of the ingredients were labeled "TOP SECRET." The work was demanding. All of Tom's internal and external organs had to be removed, labeled and put into pickling jars. Then his shaved, naked corpse had to be soaked in the secret sauce for five hours a day, after which five more hours were required in the sunlight to air dry the body, ensuring a hard, durable exterior. The process, though time-consuming and tedious, was also rewarding. Davis liked discovering new chemical equations. His newest discovered compound allowed the body to dry at a slower speed, thus ensuring a tighter exterior seal. It was essential that the treatment be repeated on a daily basis without exception. The rotting or molding of the corpse was a constant threat, especially in the early stages of the mummification process. Therefore, many times Davis had to strap Tom to a drying board in front of his drugstore at 104 Canon Avenue, as he was too busy to tend to the mummy elsewhere. The townsfolk were flabbergasted on these occasions. There was no one to file a complaint with, as Dr. Davis was chief of police, town judge and mayor.

After nearly two years of experimenting, Tom O'Neel was declared by Dr. Davis to be the most perfect mummy since the time of the Egyptian pharaohs. There were some understandable differences between the real Tom and the mummified one. Tom weighed nearly two hundred pounds when Davis claimed his corpse. Tom's mummy weighed only thirty pounds. The mummy was also about four inches shorter and had to wear a wig to hide the small .22-caliber bullet hole in his skull. However, Davis was proud of his creation, despite its minor flaws. He took the mummy of Tom O'Neel everywhere with him. If the distance was short, he would just throw the mummy over his shoulder like a sack of potatoes. Other times,

he would pull him in the little wagon that he had built especially for his ever-ready sidekick.

Tom was an interesting conversation piece. The doctor liked to joke that Tom was a much better man dead and embalmed than he ever was alive. He never drank too much, cheated at poker or picked fights like the old Tom. Dr. Davis also teased that his mummy didn't argue, eat much or snore, thus making him a more suitable companion than his dearly loved wife. Davis was often seen with Tom having lunch in the park, drinking beer at the saloon or hanging out with the old-timers at the barbershop. Leon Jenkins enjoyed propping Tom in the barber's chair and lathering him up for a shave just to watch the reaction of people passing by the shop window. Davis also found it amusing to dress Tom as a woman and pose him as if he were kissing the cigar store Indian in front of his drugstore.

If it was attention that Davis wanted by carting Tom everywhere, he sure got it. The mummy attracted not only the local tourists but the attentions of several drug and cosmetic companies as well. Davis had big plans for the new secret pickling formula. He planned to market the prized fluid to cosmetic and drug companies. The secret solution worked wonders as a mummification formula—just think what it could do for crow's feet, liver spots and piles. Unfortunately, his miracle formula never attained a patent, and his dreams of building a pharmaceutical empire were extinguished. In 1891, Dr. Davis, one of the town's founding fathers and a true Renaissance man, died from brain disease at the age of fifty-five. His last request was that he be buried where he spent his happiest days, in Crystal Hills Cemetery, not far from the stone house he built for his buddy Tom. Hundreds of people attended Dr. Davis's funeral. While at the graveside services, a group of curious children wandered into Davis's unlocked stone hut laboratory and ran shrieking from the building after discovering its gruesome secret.

A few weeks after Dr. Davis's funeral, people in town requested that the grieving widow rid the little stone house in Crystal Hills Cemetery of its awful contents and that she finally give the battered and abused Tom a respectable funeral. The mummified remains of Tom were finally buried not far from Dr. Davis, in the pauper section of Crystal Hills Cemetery.

Tom did not rest in peace for long. Shortly after his retirement and burial, the mummified corpse became the victim of two callous grave robbers. The thieves responsible for the hijinks were a day laborer from Kansas named Bruce Kring and a local homeless man, down on his luck, known as Bryan Kiper. The desperados became fast friends after bonding over an arm-wrestling match and a round of beer. Kiper joked with Kring about a

funeral that had been held that afternoon for a mummified man in Manitou. The two men had a good laugh while pondering all of the funny things one could do with a used mummy. Then Kring had a bright idea. He confided to his newfound friend that he had heard about a two-headed calf back in his home state. He figured that if they combined the calf and the mummified man, they could have a traveling freak show. They could make up a story about finding the mummy in a Manitou cave, dress him up like a Native American and market their creation as the petrified Indian from the Grand Caverns of Manitou Springs.

Late that very night, the sleazy pair of opportunists stole a wagon from the livery and drove to Crystal Hills Cemetery. It was not hard to find the mummy, as the grave had just been covered with fresh, dark soil. Next they dressed Tom up as an Indian chief and sealed him in a pine box. Then the dynamic duo hastily made their way to the train depot. While waiting for the train to depart, Kring and Kiper went across the street to a saloon, where the two men bought a round for the house and toasted to their new business venture. The partners had so much fun celebrating that they missed the train, and Tom left without them.

Officials at the railroad depot in Kansas City grew suspicious days later when the coffin-like box went unclaimed. When they pried the box open and discovered the mummy, they immediately suspected grave robbery. Two days later, Kring and Kiper arrived at the Kansas City train station to claim their hard-earned prize and were immediately arrested, booked on charges of grave robbery and thrown in the slammer. Tom's new owners sat in county jail for several days until officials received affidavits stating that there had been no grave robberies in the vicinity. Without a doubt, the responding authorities in Manitou were glad to have the buffoons out of the region and didn't want to sign an extradition to bring the fugitives back. When the thieves were released from jail, they sold Tom to a traveling carnival.

Tom's second career in life was a great success. He fulfilled his long-held dream of traveling to distant places and meeting interesting people with his lesser-known companions, a two-headed calf and a headless chicken. Tom was a curiosity and was promoted as the Petrified Indian of the Manitou Caverns. Tom O'Neel became the first mummified human to hold a full-time job. He became a celebrity and was seen all over the country. Sometimes he would have signs hung around his neck advertising a grand opening of some sort. In 1942, he was seen propped outside a bakery in Julian, California. He was photographed wearing an apron and peddling homemade cookies. Tom would be gratified to know that he finally got to visit the Pacific Ocean.

In September 1967, the *Frontier Times Newspaper* quoted Manitou historian Bill Crosby:

I heard nothing further of him [the mummified Tom O'Neel] *until the turn of the century, when my wife, our small son and I attended the Portland Fairway, were walking down the midway and heard a barker in front of a concession inviting people to see the Petrified Indian from Manitou Grand Caverns in Colorado. I suggested that we go take a look, for I thought I'd know that Indian; chances are it would be old Tom. It was. He was decked out in the same fashion buckskin clothes, stone beads, and arrowheads scattered around his body, tomahawk in one hand, only now he wore a black wig to make him look more authentic. After the barker had delivered a short lecture and the crowd had gone on, I told him that I knew the history of the "Indian," and told him the story. He finally admitted that he'd purchased Tom in Minneapolis for $2,600. That's the last I ever heard or saw Tom O'Neel. He looked so genuine, though. I bet he's still on display somewhere and making lots of money for someone.*

Over the last century, the menacing ghost of the mummified Jack Knife Tom has been seen in Crystal Hills Cemetery many times. He appears on full moon nights wearing a badly tattered Indian costume with bushy red hair sticking out from his feather headband. Foolish teenagers often disregard the warning signs that have been posted on the imposing wrought-iron gates and dare one another to unlawfully sneak into the cemetery at night. Many of the teens are frightened so badly upon seeing the gruesome, zombielike creature that they refuse to ever step inside its foreboding gates again.

Mr. Haylee nearly died of fright after coming face to face with the mummy. He stated that he was unaware of the legend of the ghost mummy that lived in the stone house. In the fall of 2010, he decided to take a walk through the lovely old grounds and discovered the curious little stone hut. The windows were all covered in thick soot, so he used his hand to wipe away the muck from the glass windowpane. When he peered inside, a man with bushy red hair and a big snaggle-toothed grin was looking back at him square in the eye. Haylee was so frightened that he ran from the hut, slipped and hit his head on a rock. He woke up in the hospital a couple of hours later, dazed and confused. Fortunately, a jogger had found him before he bled to death. The ghostly mummy of Jack Knife Tom has been haunting Crystal Hills Cemetery for more than a century and is still seen lurking in the shadows near the stone house late at night, waiting for his next victim.

CAVE OF THE WINDS SPIRITS AND THE HUCCIES WITCHES

The cave can feel your soul...it knows when you are frightened...and I am,
whenever I peer into the deep black pit, and wonder if it has a bottom.
—Page Waters, Grand Junction, Colorado

There are 265 limestone caves in Colorado, the most well known being clustered in William's Canyon. The various limestone caverns are rumored to be ancient Indian burial tombs. One of the caves has been called the deadliest and most haunted cave in America.

In 1921, the *Colorado Springs Gazette Telegraph* reported about "strange voices" heard inside the caves. The haunting voices were also heard by the Ute Indians, who believed that they were the ghost voices of their ancestors. Indian witch doctors known as shamans had held rites of passage in the sacred caverns for centuries. Death of a clansman was a time for community mourning. The bereaved would cut their hair, rip their clothes and wallow in mud as symbolic displays of their grief. Burial and funeral customs varied from tribe to tribe. However, most followed the customary practice of burning the deceased's personal property, including horses, dogs and slaves. Then the corpse was ceremoniously washed, dressed, wrapped and buried under rocks or entombed in limestone caves. Tribesmen left beads, trinkets and arrowheads as offerings.

When the Cave of the Winds was first opened in 1874, visitors were taken to the floor of William's Canyon on horseback. From there, they climbed up a steep mountain to the mouth of the cave. Adventurous guests paid a

Early postcard of Cave of the Winds.

hefty one-dollar admittance fee, which included a torch, a map and a prayer. Needless to say, several cavers have been lost to the black hole.

The Marco brothers sold Indian artifacts to tourists. The boys likened themselves to amateur archaeologists and enjoyed scavenging the canyon for arrowheads, beads and trinkets. Once, while slithering on their bellies through a narrow cave passage known as "Fat Man's Misery," they were horrified to discover that they had inadvertently crawled over a mummified man! At first they surmised that the victim had died while trying to free himself from the grasp of the eighteen-inch-wide passage, until they found a drained bottle of strychnine still clenched in his skeletal hand. The boys were mortified by their gruesome discovery and worried that they might suffer from the same consequences of the "Mummy's Curse," like the one suffered by Lord Carnarvon.

Carnarvon was the legendary benefactor of the King Tutankhamun tomb excavation. Before Carnarvon and archaeologist Howard Carter entered the Egyptian burial chamber, they observed a cryptic message scrawled in hieroglyphics over the doorway that warned, "Death shall come on swift wings to him who disturbs the peace of the Pharaoh."

The day the tomb was breached, Carter went home to find that a king cobra had broken into his house and robbed him of him of his most cherished possession. The sleeping serpent was found contently coiled in Sweetie Pie's cage. Yellow and orange feathers were scattered everywhere. Egyptian staff regarded the incident as an omen from the ghost of King Tutankhamun. Undaunted by the warning sign, the dig continued until a few weeks later, when Lord Carnarvon was apparently afflicted by the curse. The fifty-seven-year-old accidentally cut a bug bite while shaving one morning, and by early afternoon his left cheek was seriously infected, causing the man to experience severe pain, delusions and seizures. Howard Carter rushed his friend to a doctor. However, upon reaching the hospital, Carnarvon died. Legend tells that at the moment of his death, all of the lights went out in Cairo, and Carnarvon's favorite dog at his English estate howled at 4:20 a.m. before mysteriously dropping dead. Twenty-one people connected with the discovery of the tomb died early and of unnatural causes. This included two of Carnarvon's relatives, Carter's personal secretary and the suicide of Lord Westenbury. The press had a field day with all the strange deaths. Sir Arthur Conan Doyle attributed all of the strange misfortune to the "Curse of the Mummy."

The Marco brothers were so frightened upon finding the mummy in the cave that they gave up their lucrative hobby.

There were several people who claimed to be the first to discover Cave of the Winds. The most accepted story is that the Pickett boys were the founders. On June 26, 1880, a church youth group and their leader, Reverend Cross, went to Williams Canyon to explore the caves. Brothers George and John Pickett were hiking in the canyon when they were lured by an eerie sound of moaning coming from the canyon walls. They were really frightened by the mysterious noise but decided to follow the haunting sound to the top of the ridge. On the southwest side of the canyon, they found a hidden blowhole. Upon entering the cave, candlelight revealed a wonderment that would be forever etched in their memories. The mysterious underworld cavern was adorned with dazzling walls of sugar-like aragonite crystals, gypsum flowers, columns of golden-hued stalactites and burnt copper stalagmites. Silky ribbons of cascading flowstone, in exquisite hues of red, white, orange, pink and yellow, flowering alabaster and "cave bacon" seemed to flow from the floor to the ceilings.

That summer, a few inspired investors leased "Pickett's Cave," but the business venture flopped. The next year, George Snider happened upon the cave and convinced his large extended family and friends to invest in the property, which he renamed the Cave of the Winds. In 1884, the Snider clan, wanting more control in the canyon, traded half of their share in Cave of the Winds for the nearby Mammoth Cave property and christened the new cave the Grand Cavern.

Although many interesting fossils were found in the cavern, the most spectacular of its attractions was a grand organ made entirely from beautiful gold- and ivory-hued stalactites. The strange music produced by the unusual instrument had eerie, rich, clear tones and was pitch-perfect. Elmore Snider became adept at playing the unusual pipes by striking them with a handheld wand. The talented showman soon mastered such hits as "Rousseau's Dream" and "God Save the Queen." Despite the Snider clan's best efforts, business was slow. George opened the cave year round and twenty-four hours a day. He even posted a colossal electric sign on the hillside that flashed "Wonderful Cave of the Winds," which could be seen for miles. He hired Native American dancers and fire-eating monkeys, but the business still languished. Rumors began circulating that commercializing the ancient sacred canyon had brought a curse on the various land developers.

On October 1, 1886, Rose Rinehart sued the Snider clan because she believed that Mammoth Cave was located on part of her private property. Over the next twenty years, a string of lawsuits and countersuits was filed

against various parties. Two lawsuits were tried and appealed all the way to the Colorado Supreme Court. However, the suits were rejected owing to mysterious filing errors and the untimely deaths of Mr. and Mrs. Rinehart. The lawsuits and smear campaigns got as deep, dark and scary as the caves that the developers were fighting over. Locals called the quarrelsome land developers "cave men," and their absurd rivalry was known as the infamous "Cave Wars." One newspaper headline read, "Father Wants Son's Property," and another screamed, "Wife Sues Husband Over Cross Claim."

A lot of gold was mined from the pockets of the land developers, and a mountain of legal debt was incurred. George Snider's eighteen-year marriage crumbled, and his ex-wife became mentally ill and had to be institutionalized.

On May 26, 1905, the following appeared in the *Colorado Springs Gazette Telegraph*:

Insane Woman Threatened Officers with Huge Knife

Mrs. Snider, divorced wife of the former owner of the Grand Caverns, according to police officers is insane. When she was taken charge by the officers she narrowly missed killing one of them with an immense carving knife having a blade of nine and half inches in length. Mrs. Snider has been residing at a house on Ute Avenue, leading up to the pass at Manitou, and has been known to be insane for some time, but so long as her malady did not become violent the authorities did not proceed against her. Chickens and pigeons shared her house with her, roosting upon the furniture and the interior of the building was in a shocking condition. Recently, her trouble has become so serious that people residing in the vicinity became afraid to walk passed the house and the authorities determined to act. When the officers approached the house, the woman appeared and ordered them away. The officers advanced upon her in different directions and the woman drew a big carving knife from her bosom and flourished it at the approaching men. A sudden dash and she was a prisoner, with the deadly weapon lying on the ground. Screaming and fighting every step of the way, the unfortunate woman was removed to the county jail where she was placed in a padded cell to await a hearing in the county court today.

Then, a series of bizarre accidents, illnesses and deaths occurred to the various land developers and their associates. Mr. Barr, a financier of Barr Trail, had his right arm severed in a freakish carriage accident during which

his wife lost her scalp. S.W. Wright, a prominent druggist and dear friend of the Snider clan, was thrown from his horse near the cave and was found dead by two boys who were camped nearby. Forty-year-old H.E. Snider was walking through the lobby of an affluent Los Angeles hotel and was killed by a stray bullet. Deadly illnesses claimed Vera Snider and investor R.H. Rupp, both only thirty-eight years old. O.P. Snider died after a ten-day fever, and his niece, Ruth Snider, was just nineteen when she suddenly expired from pneumonia. William's Canyon was victimized by a plague of environmental disasters, like grasshopper infestations, a populous earth worm migration and several deadly flash floods.

Rumors swirled that the Snider brothers had joined a secret society and were attempting to break the curse by using magic. News of the Snider brothers' initiation ceremony into the brotherhood was leaked to the press and then was splashed on the front page of the newspaper ("Weird Spectacle in Grand Caverns").

The *Gazette Telegraph*'s newspaper account about the strange torchlight initiation ceremony noted that the cloaked initiates rode up the hillside on bareback donkeys before being blindfolded and led into the belly of a cave. Oaths were sworn, and prayers were recited while a white-robed maestro played ethereal music on a stalactite organ.

Joining the mystical brotherhood did not seem to help the Snider clan; in fact, the curse seemed even more apparent. Vicious vandalism erupted in William's Canyon. The Sniders offered a large reward for the arrest and conviction of the perpetrators; however, the assaults continued, to no avail. Finally, George Snider hired Chief Manitou, aka Robert Cayeta, to try and remove the horrible curse from the canyon. Luckily, after two long decades, the misfortune stopped. The twenty-year lawsuit was settled, and all those not yet financially destroyed or killed from the curse thanked Chief Manitou for removing the curse and restoring peace to *most* of William's Canyon.

Huccacove Cave, in William's Canyon, known as "Huccies" to locals, is still the deadliest and most haunted cave in America. Huccies was the first commercial cave in the canyon. It was owned by Tom Green and called Mammoth Cave. Unfortunately, the tourist attraction was only opened for one summer before it was bankrupted due to its sinister reputation. Tourists and locals alike were frightened by the cave's haunted reputation and did not want to tour the cavern because they knew that the rumors had merit.

Huccies is a "keeper" cave. The title of "keeper" is given to only the most dangerous and isolated cases not accessible to emergency crews.

Several people have died while exploring Huccies; some of their bodies have never been found.

In 1916, two cavers exploring by candlelight found a dead man at the bottom of a pit in Huccies cave. Years later, two other corpses were found in the exact same spot, all of them apparent victims of the seventy-five-foot cliff known as Angel Falls. Richard Rhinehart's *Without Rival: The Story of the Wonderful Cave of the Winds* christened Huccies as the deadliest cave in America.

It is easy to understand why the cave is so dangerous. Huccies is so dark inside that you cannot see your hand in front of your face, and the narrow, twisting, rubble-strewn paths require sure footing and balance. One misjudged step and the cave will keep you forever.

Perhaps another reason for Huccies' frightening reputation is because it was home to a coven of murdering black witches. The *Gazette Telegraph* posted on August 14, 1979, that two teenage girls reported a murder to Manitou Springs police chief Harry Green. They claimed that a pregnant woman by the name of Tammy had been stoned to death by a group of bloodthirsty "black Witches" who were living in a cave near Serpentine Drive. The high priest was known as Randy, and other coven members also went by unassuming names: Sunshine, Lobo, Patches and Cowboy. The evil cult reportedly lived on the blood of slaughtered animals and was supposedly looking for victims in Manitou Springs.

Corpses of dead animals began to litter the canyon floor as the black witches drained blood from rats, birds, cats and dogs and disposed of their lifeless carcasses by spitting them out the mouth of the cliff-side cavern. Oddly, canyon scavengers like crows, magpies, raccoons and even coyotes refused to dine on the easy pickings. Cave of the Winds management, in conjunction with the Colorado Springs Grotto of the National Speleological Society, put a permanent gate on the cave, but the evil coven breached the barricade several times before the entrance was permanently closed shut with a concrete cap. Sealing the cave may have been the swiftest way to evict the legendary witches, but it did nothing to mend the cave's haunted reputation.

Twenty-one-year-old Douglas Daniel, a Cave of the Winds tour guide, said that his strong Christian faith is what helped him get through two frightening experiences in 2010. The first time was when he noticed a little girl staring at him throughout his entire tour. The child's entranced gaze made him feel slightly uneasy, so when the tour was over, he kindly asked her if she was all right. Without hesitation, she looked up at him with her frightened eyes and asked, "Why did you have that red light over your head?" Doug was not wearing a headlamp during the tour and was dumbfounded by the child's

Orbs in Cave of the Winds. *Courtesy of Full Moon Explorations.*

strange question. Before he could answer, the girl's parents showed him several digital photos of an unexplainable bright red light suspended over his head. Accordingly, another tour participant showed him a video of the same crimson orb following Doug throughout most of the tour. Another time, Doug was in the cave with two witnesses when a tall, white, formless phantom creature passed right through him. He said that goose bumps spiked all over his body as he watched the being glide through the cave wall.

Don Weeks of Cave of the Winds management would like readers to know that there are several different year-round tours available for people interested in spelunking the famous caverns in Williams Canyon. Recently, the Huccacove "Huccies" Cave has been made available for serious cavers not threatened by the cavern's menacing reputation.

Cave of the Winds management implored the author to remind her readers that William's Canyon is private property. Touring the caves without permission is not only extremely dangerous but is illegal, too. Cave of the Winds will prosecute trespassers.

The Eggman

MANITOU'S MOST MENACING GHOST

My Dad and I saw the Eggman once at the penny arcade by the stone bridge. We thought he was a street performer until he vanished before our eyes.
—Sarah Reisfelt, California

There have been numerous accounts over the years, by people both sober and intoxicated, who have seen a lame man limping down Manitou Avenue late at night. Some witnesses have called local authorities to report the reclusive vagrant; however, by the time police arrive to investigate, he has slithered away into the night. He is troll-like in his features: short and slight, and he walks with a hideous limp. The black cane he clenches in his bony gloved hand is carved with curious details that look mystical in nature. A dark, moth-eaten suit hangs on his frail, skeletal body. His fedora hat is squeezed over bushy black hair, leaving his face concealed in shadow. The most disturbing observations about him, however, are that he is always seen clutching a sack of rotten eggs in one of his hands and that the distinctive scent of sulfur lingers in the air when he is near. His presence in the community gives few peace of mind.

In the spring of 1912, when most people around the world were talking about the sinking of the *Titanic*, citizens in Manitou were discussing a strange man who wandered around town at night and stank of rotten eggs. Locals started calling him "the Eggman." Locals feared him then, and they fear him still. If you call the chamber of commerce to enquire about the Eggman, they will politely laugh it off and then hang up before you can

press them with further questions. Who can blame them? The rumor of this menacing ogre stalking late-night bar-hoppers is enough to destroy a local economy that is largely dependent on the revenue from tourism to survive. Throughout the tourist town's long, illustrious history, there have been certain years that have had unexplained lapses in economic growth. The one factor that they all had in common was Eggman attacks. City leaders can only speculate on whether the slump in the local economy those years can be blamed on the frightening phantom menace. So for now, the subject remains taboo, and the Eggman has been relegated as only a silly ghost story.

However, dozens of people allege to have had dangerous encounters with the Eggman over the years; thankfully, a few of them have lived to tell about it. One of them is Gail Bailey, a retired artist, writer and poet whose family history of homesteading in the region dates back to the 1800s. In fact, Gail is so proud of her family's local heritage that she prominently displays "pioneer plates" on the back of her royal blue 1989 Cadillac. Gail has known the author for more than thirty years and agreed to be interviewed for this book, but only out of devotion to their enduring friendship, as the memory of that horrific evening is still quite painful. The two women had lunch together at Marilyn's Pizza House in Manitou Springs on October 7, 2010, while Gail shared her horrific account of that evening:

On the evening of January 28, 1988, my friends met at the Townhouse, or Clown House, as we jokingly called it back then. We had a great time dancing and pigging out on house specialties like Roger's Rocky Mountain Oysters; Roger was the owner, not the bull! A local favorite band, Shakedown Street, played that night. Shakedown was known for playing Grateful Dead hits and always attracting a rowdy crowd. It was late when I stepped outside the smoky bar. I decided to take the long way home so I could stop at Tubbies Turn-Around for a quart of milk.

I began strolling down Manitou Avenue. It was lightly snowing outside, and the temperature was just cold enough to be invigorating. I noted a peculiar sulfuric odor wafting through the air. I recall wondering where the source of the smell was. Manitou had several mineral springs in town, and none of them exuded foul odors. As I shuffled toward the penny arcade, I fondly remembered a Girl Scout field trip to Manitou Springs. My best friend, Susie Verhey, and I sneaked into the arcade and put a penny into an old antique machine, which promised to show a naked woman. The naughty harem girl's flickered dance movements were outrageously funny as we watched her haltingly strip down to her pasties and panties. Just as

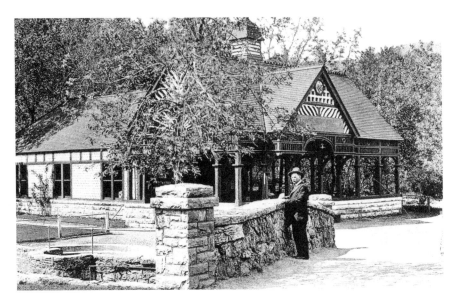

Old postcard of Stone Bridge in Soda Springs Park, where the Eggman is often sighted.

we turned the crank to see the grand finale, our leader grabbed us by our ponytails, and the curtains closed on our first peep show. The thought made me laugh out loud, and the fond memory seemed to warm my chilled bones.

It was so quiet and peaceful that night. I can still vividly recall how colossal snowflakes descended from the dark skies, and everything around me seemed to be basking in the milky hue of the moon. I was enjoying my late-night stroll until I heard a startling sound like a distinct thump, followed by a long drag. I surmised the clatter must be coming from someone who walked with the assistance of a cane. I recall wondering why any disabled person in their right mind would be trying to walk around in the deepening snow. However, I shrugged it off and marched along while thinking about all the colorful characters that made our town unique. There was the highly regarded artist Rocky and his old dog everyone knew as Puppy. Then there was Cosmic Joe and his girlfriend, Gypsy, and the eccentric cave dwelling millionaire, affectionately known as "the Big Hearted Rabbit"—just to name a few. Some Manitoids you come to know by face, others by name, moniker or alias. One Manitoid, a cook at Adam's Mountain Café, had just legally changed his name, and learning about it on a National Public Radio station that morning was almost as surprising as the actual name itself: "Purple Frog Eight Oaks Rainbow Star." I remember chuckling to myself about it, as I

stopped walking to light a cigarette. Then I noticed that the odd sound I heard a few minutes earlier was definitely getting closer. I casually glanced around, and after surveying the streetscape, continued my quest.

I was almost to the penny arcade when I realized that the putrid smell of rotten eggs had permeated the air and was making me feel nauseated. To make matters worse, the thump-drag sound was getting louder, and its reverberation began to make my teeth chatter. I stopped again, and the noise halted accordingly. It was so quiet you could have heard a pin drop. I looked completely around, surveying the avenue for any signs of life. Everything was covered in a thick blanket of snow. I felt like I was in a bad science fiction movie where everyone in town had vaporized but me. I fantasized that the powdered snow was the deadly chemical agent and the noxious odor in the air resulted from the residue. I fantasized that this had to be the work of ingenious Soviet Union terrorists. What an ironic way to end the Cold War, I thought, than with toxic snow. As I trekked toward the penny arcade, I heard the frightful sound again, only now it was way too close for comfort. I ran as fast as I could to the penny arcade and desperately searched for someone, anyone, who could help me. I had

The penny arcade is haunted by the devious Eggman. *Courtesy of Catherine Comings.*

a foreboding fear that I was about to be murdered. I had heard about the infamous Manitou black witches and was scared that maybe they were hunting for a human being to sacrifice! I could hear the sound getting closer and was maybe only a couple hundred yards away. I peered from around the corner, up and down Manitou Avenue, but there was not a single soul in sight. I was completely alone—the only footprints in the snow were my own. That was the moment I realized that I was being stalked by something paranormal in nature.

My grandpa taught me that whistling past graveyards warded off evil spirits, so I started whistling as loud as my frozen lips would allow. I remember I was almost through the arcade when I noticed my scarf had slipped from around my neck and had fallen on the ground. I bent over to retrieve it, and as I rose up, I caught an image of myself in a store glass window. Standing directly behind me was the reflection of a short, hairy man holding a basket of rotten eggs in one hand and a black cane in the other. He was wearing a dark suit, hat and he was faceless. The gruesome image instilled such fright in me that I laid victim to my fear. I closed my eyes when the hideous creature raised his cane high up over head, and I braced for what I knew was sure to be a fatal blow.

The next thing I remember was waking up in Penrose Hospital. The nurse informed me that I had been brought in three weeks earlier by a snowplow driver. I will never forget that when I asked the nurse if the snowplow driver was short, hairy and smelled like rotten eggs, without looking up from her clipboard, she dryly responded, "Of course. They all do, honey." That is when I knew I could never share my story about what happened that night with anyone else but you, until now. I was psychologically traumatized by the attack and will likely suffer from relentless sleep paralysis nightmares for the rest of my life.

The author was introduced to Bryan Deguy, a local historian, fifteen years ago through Penrose Public Library in Colorado Springs. Deguy is, remarkably, the only known survivor of two Eggman attacks. He says that he is grateful for the experiences because they gave him insight. However, he implied that the lesson didn't come cheap and believes that the assaults are likely the reason that he never married or had a family. He agreed to be interviewed in hopes that his sad story might prevent someone else from repeating his mistakes. The author interviewed the recluse on February 8, 2011, which was incidentally the fourth anniversary of the most resent assault:

I have never seen the Eggman, but I know that he is a real, and his devious attacks ended up costing me the only two women that I have ever really loved.

The first time I was standing outside La Chemere gift shop, on Manitou Avenue. It was early July. I remember it was a hot summer evening, and a strong scent of sulfur was in the air. I assumed the offensive odor was either from fireworks or from the nearby Navaho Spring. I walked around the corner to investigate but could no longer get a whiff of it. When I got home to give my girlfriend the surprise gift I bought her, she threw the turquoise earrings at me and screamed that I stank and wouldn't let me in the house. I ended up sleeping at a friend's that night. When I went back home the next morning, all her things were gone, and the "Dear John" note taped on the on the refrigerator simply said, "There is no excuse for smelling like a dirty old wet dog, goodbye forever, Audra." I know it's kind of funny now, but believe you me, it cut like a knife when it happened.

The second time I loved and lost, due to an unfortunate encounter with the Eggman, was with this beautiful girl named Sherri Dupree. She was as pretty as a china doll. It was our first date, and I really wanted to impress her, so I took her to the Loop, one of my favorite Mexican restaurants. We were walking down the sidewalk toward the Royal Tavern when I noticed that same strange odor, like rotten eggs. We continued walking another block, when I realized the smell was following us. It was then that I figured (how can I politely say this?) Miss Dupree was crop dusting her bean burrito all the way down the sidewalk. When we got to the Royal Tavern, I tried to be as dignified as I could and politely ask her if she was gassy and needed some medicine; after all, I would not want her playing pool in that condition.

That was our first and last date, and I never saw her again. It's a shame, too; I thought she was going to be the mother of my children. I was really heartbroken over that woman for a very long time. Last time I heard anything about her, she had run off with a truck driver who was a dead ringer for Willie Nelson.

The similar accounts, though years apart, made me want to investigate the history of Manitou Springs to see if I could dispel the mystery. I asked a good friend of mine, an engineer and owner of "Four Strong Winds," to survey Manitou Avenue for leaking gas, but nothing could be found. I know this may sound really crazy, but I started hearing rumors in town about Eggman sightings and victims talking about a foul stench had "attacked them" while walking around Manitou Avenue at night. Some victims have even claimed that it took them several tomato juice baths to get rid of the

gangly smell. I decided to dig further, and that's when I found an article that explained everything. It was published in the Pikes Peak Journal *on May 31, 1912—and might help shed light on the century-old mystery:*

ENDS LIFE IN MANITOU SALOON; UNKNOWN MAN SHOOTS SELF IN RIGHT TEMPLE; EFFORTS TO ESTABLISH HIS IDENTITY HAVE THUS FAR BEEN FUTILE—WAS ABOUT 30 YEARS OLD

An unknown man, about 30 years of age, committed suicide by shooting himself in the head with a .38 caliber revolver at 1:45 o'clock last afternoon, in the Tavern Saloon, at 220 Manitou Avenue. The man entered the saloon, carrying a small sack of eggs, which he had just bought at A.M. Wilson's store and went into the card room at the back of the building. He ordered a bottle of beer, and when the bartender, R.H. Robison entered, he was eating one of the raw eggs. Robison brought him a small glass in which to put the eggs, and left him alone. A few minutes after he heard the muffled report of a shot, and rushed to the room, where he found the stranger, with his head bowed upon the table and with a bullet hole in his right temple. The pistol had dropped from his extended hand. When coroner Jackson arrived, a search was made of the man's clothes. But no marks of identification were discovered, save the laundry mark which was "J.B." In a pocket was found a Denver campaign card, on which was penciled an address "127 south Tejon Street." He was found to be wearing an artificial limb, his right leg being cut off above the ankle. A $5 bill was found in his wallet. He carried a Waltham seven-jewel watch with a gold filled case. The suicide was five feet tall, was smooth shaven, and had brown eyes, black curly hair, and small delicate white hands. His features were regular. He wore a blue suit with small white stripes. The suit bore the trademark of Daniels and Fisher of Denver. His soft white hat bore the makers name "Boogher, Force & Goodbar Hat Co." He carried a size 5 tan gloves. The pistol was a small "vest pocket" hammering revolver.

After I found that article, everything made sense to me. The unknown suicide victim may have had a gambling problem, as his pants pocket held several ripped betting tickets from the Denver racetrack. His addictive

behavior may have been the precursor to him taking his life. The souls of suicide victims are often lost, and that is why the Eggman still haunts the streets at night, polluting the fresh mountain air and terrorizing his unknowing victims.

Brian started a support group for survivors of Eggman attacks, but only a few people took him seriously. Unless you have had an encounter with the Eggman, you could never possibly know how frightening it is. Many of his victims suffer in silence, betrayed only by the foul stench that follows them home at night. Brian Deguy speculates that the reason that so many Eggman attacks go unreported is because of the shame involved. It would take a lot of moxie for someone to do the right thing and walk into the Manitou Springs police station and file a report, but most people admit that they would be too embarrassed and fear that the police would never take them seriously or may even cite them for false reporting.

Mr. Deguy is a concerned citizen and has taken on a crusade of sorts to spread the word about the evil Eggman. He exclaims that you are only as sick as your secrets, and he had plans to rid Manitou Springs of its shameful and dirty little secret forever. So he asked some wise women from Black Cat Bookstore to banish the ghost from the streets of Manitou Springs forever. When the American Indian smudging ritual failed, he requested the assistance of demonologist Robert Candless, but nothing so far has helped.

The town of Manitou Springs still suffers in silence, embarrassed for its situation but not being able to cry out for help. Perhaps city government leaders fear that Manitou Springs will be further ostracized from its more conservative neighbors. Meanwhile, the vengeful spirit of the Eggman still haunts the streets of Manitou Springs at night, unimpeded by the law of government or physics.

Other Hauntings

M anitou Springs has an illustrious history of being haunted. Obviously, all of the reputed haunted locations in town could not be reported in this book. However, a few honorable mentions have been included.

IRON SPRINGS CHATEAU DINNER THEATRE
444 RUXTON AVENUE
There is an active poltergeist that roams the building, turning lights on and off, sliding chairs across the hardwood floors and causing havoc in the ladies' room, as his reflection is often seen in the bathroom mirror. He also enjoys "goosing" women on their rear ends as they exit the restroom. The flirtatious poltergeist is thought to be a maintenance man named Rupert, who drowned after being overcome by carbon monoxide fumes, falling into the Iron Springs holding tank.

STAGECOACH INN RESTAURANT
702 MANITOU AVENUE
A "woman in white" is often seen by the upstairs windows. Longtime employee "Jazz" is a self-professed "ghost magnet" who claims to be sensitive to paranormal energies. He has also seen the woman upstairs and believes that the spirit is a woman named Tiffany from Leadville who committed suicide after being stood up by her fiancé at the stage stop, and she still lingers by the upstairs window, looking outside as she waits for him.

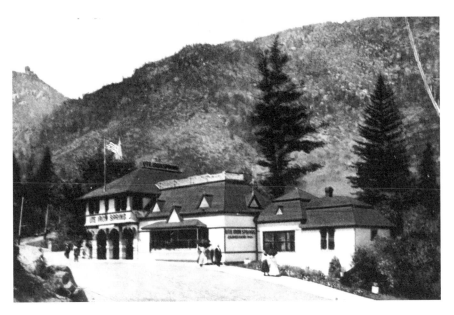

Old postcard of the Iron Springs Chateau, which is haunted by a flirty poltergeist known as Rupert.

Early postcard of Stagecoach Inn Restaurant, which is haunted by a lady in white known as Tiffany.

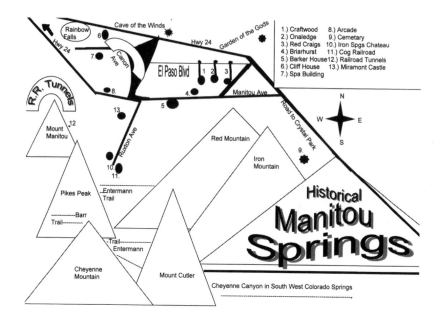

Map of haunted locations in Manitou Springs. *Courtesy of Sharon Kay graphics.*

THE LOOP
965 MANITOU AVENUE
The Mexican restaurant is well known for serving the world's most deadliest margaritas, but no one knows if that is the reason for it being haunted.

THE CRAFTWOOD INN
404 EL PASO BOULEVARD
The arts and crafts–style building was built as a coppersmith shop in 1912 but is now known as an award-winning restaurant that specializes in fine Colorado cuisine. The building is known to be haunted by a "boy in blue," who is often seen by the caretaker's cottage.

THE SPA BUILDING
934 MANITOU AVENUE
It was originally built as a bathhouse in 1920. Rumors were that the building was cursed by the Indians because it was built over one of their most sacred springs. The building has been flooded many times, leading

many to speculate that the building was cursed. The Murphy Group saved the dilapidated building from the wrecking ball and restored it back to its former glory. As a precaution, before the building was reopened in 2000, the developers invited representatives from local American Indians to bless it.

RAINBOW FALLS
BASE OF UTE PASS
Rainbow Falls is believed to be haunted by spirits of two men with the surnames of Bagby and Schmidt. Their wagon was ambushed by highwaymen on their trip home from Leadville. Their bullet-riddled bodies were discovered in a shallow grave near the foot of the falls. Their killers were never found. Gunfire has been heard by the falls for decades. Some people argue that the sound is just the backfire from passing automobiles. However, few know that the sound was reported long before the Highway 24 bridge over the falls was built.

THE DULCIMER SHOP
740 MANITOU AVENUE
The dulcimer shop on Manitou Avenue was once Johnny Nolan's Silver Dollar Saloon. Silver dollars were once lacquered into the floor, and the basement was at times used as a makeshift morgue. The building seems to be haunted, but no one knows the identity of the longtime resident banjo-playing spirit.

HEART OF MANITOU DAY SPA
1 PAWNEE AVENUE
The building was constructed as a boardinghouse for schoolteachers in 1912. The owner claims that the building is haunted by a benevolent spirit. Several people have seen a white apparition on the staircase that disappears into a white mist.

THE BANK OF MANITOU
814 MANITOU AVENUE
The building was constructed to fit the lot by Jerome Wheeler, one of the town's founding fathers. It is now known as Manitou Jacks, a jewelry store that specializes in American Indian jewelry. The building is believed to be haunted by a playful spirit that likes to hide things from employees.

MUSHROOM MONDAY
937 MANITOU AVENUE
The gift shop is haunted by a friendly spirit that employees call "Charlie."
The apparition is very lifelike but is only seen from the waist up, indicating
to the owner that he is standing on the original foundation.

THE AVENUE HOTEL (BED-AND-BREAKFAST)
711 MANITOU AVENUE
Owner Gwen Davis says that the home was built as a boardinghouse in 1886
and is haunted by several spirits. Ghost hunters have reported the home to
be haunted by a couple of children, as well as a coachman who once resided
there.

THE ANCIENT MARINER
967 MANITOU AVENUE
The bar is believed to be haunted by a prankster ghost named Joey, an
effeminate, six-foot-six bartender who worked at the lounge back when
you could still decipher the tale of the "Ancient Mariner" etched into the
copper bar top. Joey was only twenty-five when he was killed in a motorcycle
accident. Ever since his untimely death, a tall, cross-dressing ghost is seen
playing pool after hours.

MOUNT MANITOU INCLINE
FOOT OF PIKES PEAK
The Mount Manitou Incline was closed in 1991, and the snack bar on the
summit was torn down. A cook named Spencer had a heart attack while
flipping burgers in the kitchen. Spencer's lifelike apparition was seen
immediately after his death and is still seen lying on the old foundation to
this day.

AFTERWORD

B elief in ghosts is widespread and predates written history. Certain religious rites, funeral customs, exorcisms and ritual magics were used to communicate with the spirits of the dead. In traditional accounts, ghosts were believed to be deceased people looking for vengeance—or stuck here because they had unfinished business. Some people think that they linger because they are too attached to the physical world or because they refuse to believe that they are dead. The appearance of a ghost has also been regarded as an omen or portent of death. Seeing one's own ghost, or "Fetch," was also thought to be a harbinger of death. Another widespread belief is that ghosts are misty or ethereal. Anthropologists link this idea to early beliefs that the soul was a person within a person. Primitive man believed that you could see your soul while exhaling in colder climates—that it appears visibly as a white mist.

At the close of the nineteenth century, Darwin's new theory of evolution gave birth to a golden age of rationalism among scientists and philosophers, and a counter wave of spiritualism took over the popular imagination. Physicist Albert Einstein believed that energy, like matter, can neither be created nor destroyed—it could merely be transformed from one state to another. Perhaps that is why inventor Thomas Edison tried to invent a device to detect and communicate with the soul. He believed that all living creatures were composed of what he called "life units." His theory was that these life units contained memory and could be changed but not destroyed. Edison worked for years to build a piece of scientific apparatus that could

detect these life units and act as an amplifier, even after the death of a body. Edison invented the first commercial light bulb, phonograph and motion picture projector; unfortunately, his ghost communication device remained incomplete at the time of his death.

In 1937, Russian electrician Semyon Kirlian used the properties of electricity to create stunning photographs. First, he placed a piece of unexposed film over a piece of metal, and then he placed an object on the film. Next he grounded a high-voltage, high-frequency generator on the plate and touched the other end of the wire to the object. As the film was exposed, a natural electrical discharge created a stunning halo, or iridescent aura, around the object. Kirlian photography, as the phenomenon became known, made paranormal believers claim that the photographs were proof that an invisible life force exists in all living things and manifests itself in the form of an aura.

My friend Dr. Claude Swanson wrote a wonderful book called *The Synchronized Universe*. It is a must read for the paranormal enthusiast. The book is written in layman's terms and is a great presentation of scientific evidence proving the existence of the paranormal. In his book, he suggests how present physics can be modified to understand and explain strange phenomena. Dr. Swanson also makes a leap by attempting to heal the ancient split between science and spirituality.

Advances in digital photography and sound recording equipment have made ghost hunting more popular today than ever. I hope that you enjoyed this collection of ghost stories from Manitou Springs, Colorado. Hopefully I will be writing a book about haunted Colorado Springs next year, so stay tuned. Happy ghost hunting!

BIBLIOGRAPHY

Asfar, Dan. *Ghost Stories of Colorado*. Ashburn, WA: Lone Pine International Publishing, 2006.

Brunk, Ivan, W. *Crystal Park: The Gem of Pikes Peak*. Colorado Springs, CO: Old Town Publishing, 1990.

Cunningham, Sharon. "The Barker House." Unpublished manuscript, 1985.

Daniels, Bettie Marie, and Virginia McConnell. *The Springs of Manitou*. Denver, CO: Sage Books Publishers, 1964.

Davant, Jeanne. *Wellsprings: A History of the Pikes Peak Region*. Colorado Springs, CO: Gazette Enterprises, 2001.

Dody, Marilou, and Don Childers. *Haunted Places in the Shadow of Pikes Peak*. Colorado Springs, CO: self-published, 2010.

Harrison, Deborah. *The Cliff House*. Manitou, CO: Historic Manitou Springs Publishing, Inc., 2007.

———. *Images of Manitou Springs*. Charleston, SC: Arcadia Publishing, 2003.

Kaelin, Celinda R., and the Pikes Peak Historical Society. *Images of America: American Indians of the Pikes Peak Region.* Charleston, SC: Arcadia Publishing, 2008.

Lewis, Allen C. *Images of America: Railroads of the Pikes Peak Region, 1870–1900.* Charleston, SC: Arcadia Publishing, 2004.

Mensing, Marcia. *Miramont Castle: The First Hundred Years.* Manitou, CO: Manitou Springs Historical Society, 1995.

Ogden, Tom. *The Complete Idiot's Guide to Ghosts and Hauntings.* Indianapolis, IN: Alpha Books, 1999.

Pearring, Joanne. *The Walking Tour.* Manitou Springs, CO: Text Pros, 1983.

Rhinehart, Richard. *Without Rival: The Story of the Cave of the Winds.* Virginia Beach, VA: Donning Company Publishers, 2000.

Swanson, Claude, PhD. *The Synchronized Universe.* Tucson, AZ: Poseidia Press, 2003.

Wilcox, Rhoda Davis. *The Bells of Manitou.* Manitou Springs, CO: Martin Associates Publishing, 1973.

ABOUT THE AUTHOR

 S tephanie Waters has traveled throughout Europe, Africa, Mexico, Canada and the United States. Though she has lived in Oklahoma, California and Texas, she has spent most of her life in Colorado and is proud to call Manitou Springs home. Stephanie graduated from Coronado High School in Colorado Springs. She attended the University of Colorado in Colorado Springs and has a degree in liberal arts. She is the owner of Blue Moon Haunted History Tours in Manitou Springs and is a self-professed history geek, artist and mountain mama.

In The Heart Of Manitou

Words by EVA JOHN

Music by LEO FRIEDMAN

Oh, the cool air of the moun-tains ____ Is found in a
From east to west in mid sum-mer ____ Tour - ists trav - el
Its moun - tains, high - ways and can - yons ____ Al - lure man - y

ci - ty out West! ____ And its sun - shine and show'rs to -
man - y a mile ____ Just to reach the heart of that
tour - ists each year, ____ While parks with their bands and a -

geth - er ____ Help make it the land of the blest. ____
ci - ty ____ And view won - ders real - ly worth while. ____
muse-ments, ____ Make pleas-ure for all who go there. ____

E-31-S